When Sarah Palin Came to Town

·COPPER RAVEN PRESS·

JUNEAU, ALASKA

When Sarah Palin Came to Town

First Edition Copyright 2011

Second Printing 2012

by Tony "Toe" Newman

Published by Copper Raven Press,
308 Distin Avenue, Juneau, Alaska, 99801

Printed in the United States of America.

While inspired by actual events and people, the essays and cartoons in this book are based solely on the opinion and imagination of the author.

ISBN 978-0-615-56317-6

For further information visit Toe at sarahpalincartoons.com.

CONTENTS

In memory of John Caouette

INTRODUCTION

This collection of cartoons follows Sarah Palin's career from her first bid for statewide office in Alaska to the present. Most of these cartoons were originally published in the *Juneau Empire*, the daily newspaper for Alaska's capital city, where I've lived since 1994. A few have been partially redrawn and reformatted for this publication, but most appear here as they first appeared in print. This collection also contains many cartoons never published before or that were developed specifically for this collection.

Before 2008 the questions Alaskans would get from outsiders were typically concerned with fishing, polar bears, or the darkness that envelopes us in winter. Now we are accustomed to questions about Sarah Palin. These questions come from individuals who love her and don't understand why others don't; or they come from people who are baffled by her appeal. These cartoons and essays are intended to provide a glimpse into the Alaskan experience of Sarah Palin as it unfolded, real time, as a response to both perspectives. This collection also is intended to help my fellow Alaskans—Juneau residents in particular—relive this unique period in our recent history, and process our complex relationship with this public figure. This should be healthy for us.

I'M A PARASITE.

I'LL BE THE FIRST TO ADMIT IT.

BUT THEN, ISN'T EVERY EDITORIAL CARTOONIST?

WELCOME!
EDITORIAL CARTOONIST
CONVENTION

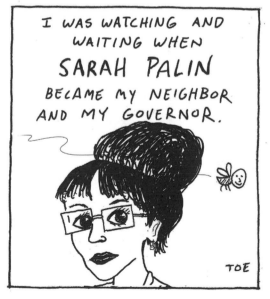

WE WATCH AND WAIT FOR RIPE TARGETS.

BLAH, BLAH, BLAH...

BLAH, BLAH, BLAH—SCANDAL!

NEWS

WE MOVE FAST WHEN THESE TARGETS MAKE THEMSELVES VULNERABLE.

FRIENDS, LET US APPEAL TO OUR BETTER NATURES...

WE STRIKE QUICKLY...

...BUT, ASIDE FROM A MILD STING, THE EDITORIAL CARTOONIST DOES NO LASTING HARM.

FRIENDS! DUM-DEE-DUM...

IT MAKES NO SENSE TO KILL YOUR HOST.

I WAS WATCHING AND WAITING WHEN SARAH PALIN BECAME MY NEIGHBOR AND MY GOVERNOR.

TOE

ALASKA MEETS SARAH PALIN

May, 2002

Only a few Alaskans knew anything about Sarah Palin prior to her run for lieutenant governor in 2002. Watchers of Alaska politics might have known she'd been a city council member and mayor in little Wasilla, that rapidly growing, distant suburb of Anchorage, a small town known for its northern hillbillies, incest, and meth labs (or at least cruel jokes about them); that she was young and charismatic; maybe that she had been a high-school basketball player and beauty contest winner.

As she ran for lieutenant governor she promoted herself as a hard-core fiscal conservative. This wasn't much of a claim in a crowded field of Republicans all claiming to be rock-solid conservatives. Her opponents also had an advantage of established track records in statewide lawmaking. They were familiar figures in the news and on the statewide TV channel that broadcasts the state Legislature's hearings and press conferences. Outside Wasilla and the Matanuska-Susitna Valley, Sarah Palin was relatively unknown.

If the lack of familiarity with Sarah Palin gave her opponents an advantage, though, her outsider status conveyed another kind of benefit—an ironic kind. We scanned the list of potential candidates in the Republican primary and felt a tepid sameness about everybody else: all middle-aged, big-boned politicians who'd plodded through long careers in the Legislature, now making a next, unsurprising step toward the lieutenant governor's office, a high-profile job with almost nothing to do. We could vote for one as well as any other and probably have gotten pretty much the same public policy. But Sarah Palin—young, breaking out from the most dynamic part of the state, relatively unknown but likely to have a bright future—this was something new, and something a lot of Alaskans wanted to know better.

ALASKA'S CHOICES IN THE 2002 REPUBLICAN PRIMARY FOR LT. GOVERNOR

©TOE

LOREN LEMAN:
LONGTIME
LEGISLATOR
AND
POLITICAL INSIDER

GAIL PHILLIPS:
LONGTIME
LEGISLATOR
AND
POLITICAL INSIDER

ROBIN TAYLOR:
LONGTIME
LEGISLATOR
AND
POLITICAL INSIDER

SARAH PALIN:
SOMETHING
NEW

Here in Juneau we wanted to know something very specific. When *any* candidates for statewide office expresses an interest in our votes, Juneauites need to establish one thing from the outset: Do they support Juneau as Alaska's Capital City?

We ask this question because state government matters to us—it's the foundation of our economy and of our identity. Twenty-four percent of all Juneau jobs are state government jobs. In 2010 the 4,221 state employees working in Juneau earned $210 million in wages. But being the state capital means more than just jobs; it's what our town is *about*. The business of government is as woven into the identity of Juneau as the forests, mountains, and waterways that surround us. Our armies of clerks, accountants, rule-writers, technicians, program managers, and other bureaucrats may joke about being cogs in the machinery of democracy, and they may count the years and days until their retirements, but they also take great pride in public service, and the vast majority take care to be productive every day. This is undoubtedly true of workers in all state capitals. But Juneau lives in an almost permanent state of paranoia about its designation as the seat of state government. Our fear is that the rest of our conservative state will finally have its fill of our city's isolation and relatively progressive politics and vote to move the capital—wholesale or piecemeal—out of our funky little town of endless rain and brightly painted houses, and up to Alaska's much more populous south central region.

This is what we learned quickly about Sarah Palin: in 2001 she had signed a petition to move the Alaska State Legislature's 120-day regular sessions to her own neighborhood. "Our arms are wide open for the Legislature to meet here" in the Mat-Su Valley, she stated at the time. She suggested that loss of the Legislature wouldn't really hurt Juneau anyway, as our strong summer cruise-ship and tourist industry would guarantee that our economy would remain healthy.

That was before she began her campaign for lieutenant governor, however. As the campaign got underway, and she waded into southeast Alaska for support, she distanced herself from a ballot measure that would move the Legislature out of Juneau. She expressed concerns about the initiative in a forum before Juneau's Chamber of Commerce, and asserted that she was being unfairly painted as unfriendly to Juneau. In the end, the ballot measure would be widely defeated in the same election Sarah would lose just narrowly.

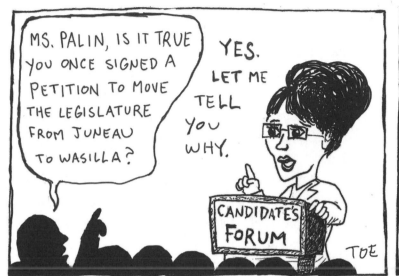
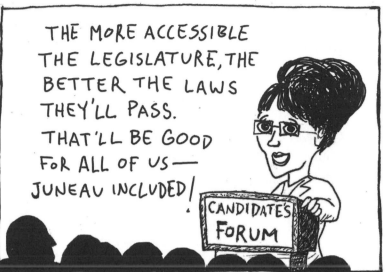
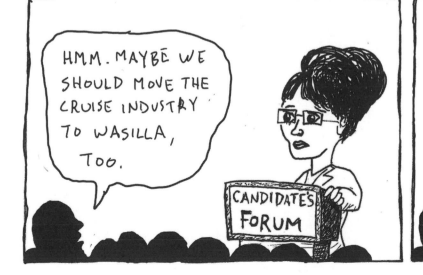
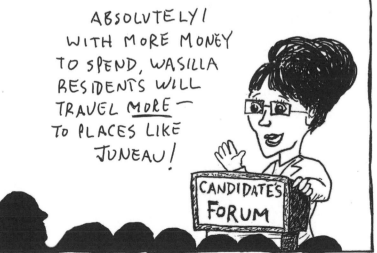

When Loren Leman won the primary for lieutenant governor he must have felt fortunate to be teamed with the Republican nominee for governor, Frank Murkowski. (In Alaska, the lieutenant governor runs separately from the governor in the primary election, and the party nominees for each office are then joined together as a party ticket in the general election. We know, it doesn't make a lot of sense.) Murkowski, our longtime junior U.S. senator, said he wanted to return to Alaska to rescue us from stagnant resource and economic development. The state's conservatives liked what they heard, and handed him more than 70% of the Republican primary vote.

Loren Leman won—but just barely. Sarah Palin came in a close second in the statewide total. (In Juneau, where we were still suspicious of her capital move intentions, she came in fourth.) Moreover, she only spent $52,023 compared with Leman's $230,402. It was an impressive result for a political newcomer. Sarah Palin went on to be a good party player and campaign for Murkowski/Leman in the weeks before the general election. She would accept a patronage position with their administration after they won, and we would forget about her.

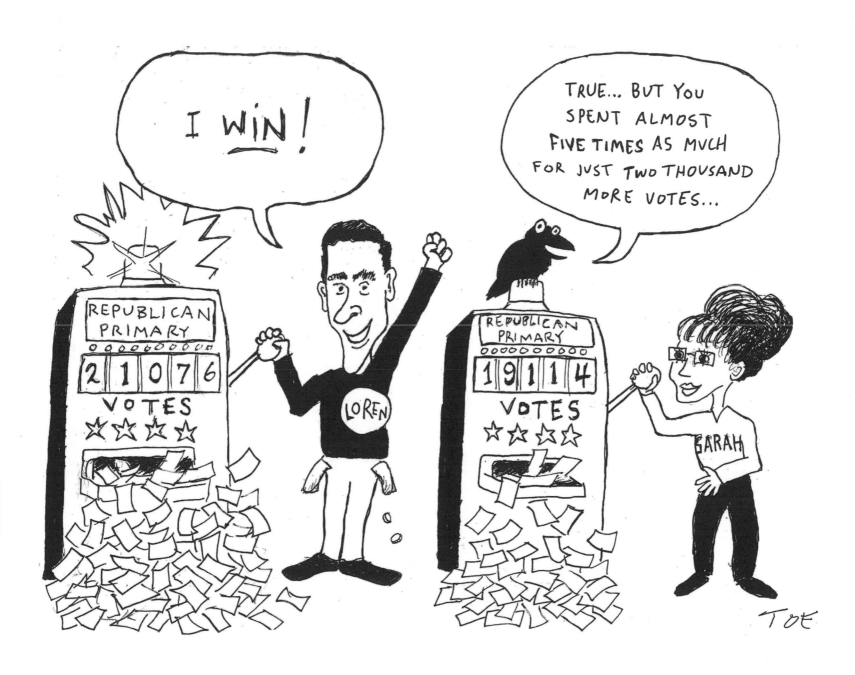

OIL, GAS, AND ETHICS COMMISSIONER

February, 2003

She re-entered our consciousness less than a year later, in the episode that would establish her reputation as an independent leader with high principles.

New Governor Murkowski gave Sarah Palin a couple of choices for positions in his administration, apparently as much out of gratitude for her support on the campaign trail as recognition of her rising status in the Alaska Republican Party. She accepted the post of Chairwoman and Ethics Chair of the three-member Alaska Oil & Gas Conservation Commission.

It may not sound like the most exciting thing, but the position was a sensible move for someone seeking to understand Alaska and its economic engine better. The taxes and royalties that the oil and gas industry pay to the state generate the overwhelming majority of Alaska's revenue—almost 90% of unrestricted general funding. As a member of the commission, Sarah was expected to help ensure that oil and gas fields operated efficiently; that wells were safely constructed and operated; and that producers followed environmental protection regulations and laws. The job paid well, especially considering she had no experience or training in the field: $122,400 a year.

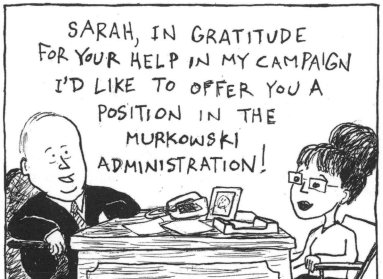

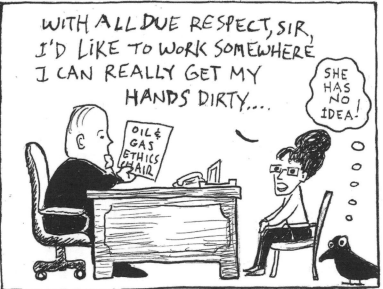

Sarah Palin wasn't the only person Murkowski appointed to the Commission. The panel had two open seats, and to the other he named a big, silver-haired man named Randy Ruedrich. Mr. Ruedrich, a petroleum engineer, might have seemed an entirely appropriate figure to appoint to a seat reserved for a petroleum engineer. Except for two things: he also happened to be chairman of the Alaska State Republican Party, and he maintained very close relationships with the companies he was regulating.

As the two of them began their service, Sarah began hearing complaints from staff and the public about Ruedrich: That he was too closely involved in cases being investigated by the commission, including one involving a company for whom he'd recently worked and from whom he continued to receive payments. That he shared too much information with oil and gas officials over legislative ideas. That he did not represent himself as a neutral commission member in public forums, but rather as a booster of the industries he was supposed to be regulating. And that he was using commission time and resources to fundraise and conduct business for the Republican Party.

Sarah found herself stonewalled in trying to work with the Murkowski administration and get guidance on how to deal with these issues. Nobody from the governor's office would return her phone calls and emails. Ruedrich's ethics disclosure forms were not made available to her. Her offers to counsel Ruedrich on his potential conflicts of interest were dismissed and ignored.

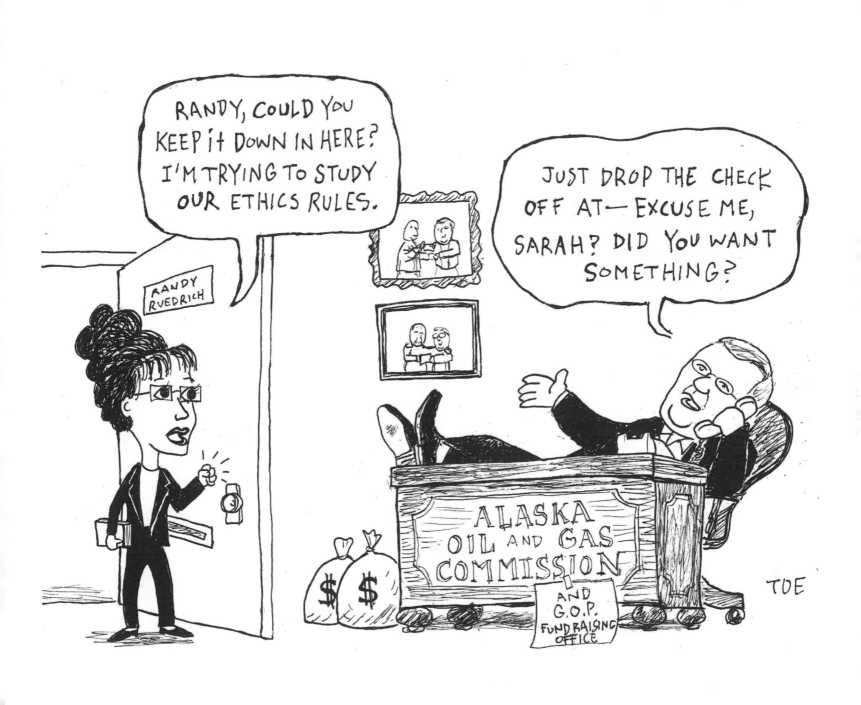

December, 2003

Most of this unfolded without our awareness. Alaska's ethics laws at the time prohibited Sarah from speaking about the escalating concerns and eventual investigation with anyone, including the media. But Alaska is simply too small a state, population-wise, for almost anything to remain completely confidential. The public could see the potential conflicts of Ruedrich serving as Republican Party chair at the same time he served as an oil and gas commissioner, such as when he joined with oil industry executives to host a fundraising event for a Fairbanks mayoral candidate in September 2003.

In November he resigned from the commission, stating that his work had become an unnecessary burden on the Republican Party. Sarah, meanwhile, was still trying to determine whether or not an investigation in Ruedrich's activities would proceed. She grew increasingly frustrated that she could not explain to fellow Alaskans what, exactly, was going on under her presumed oversight. She resigned in January 2004. The full story of what happened wouldn't be revealed until November of that year, after the state's investigation of Ruedrich's activities was complete. Ruedrich admitted to wrongdoing and paid a $12,000 fine.

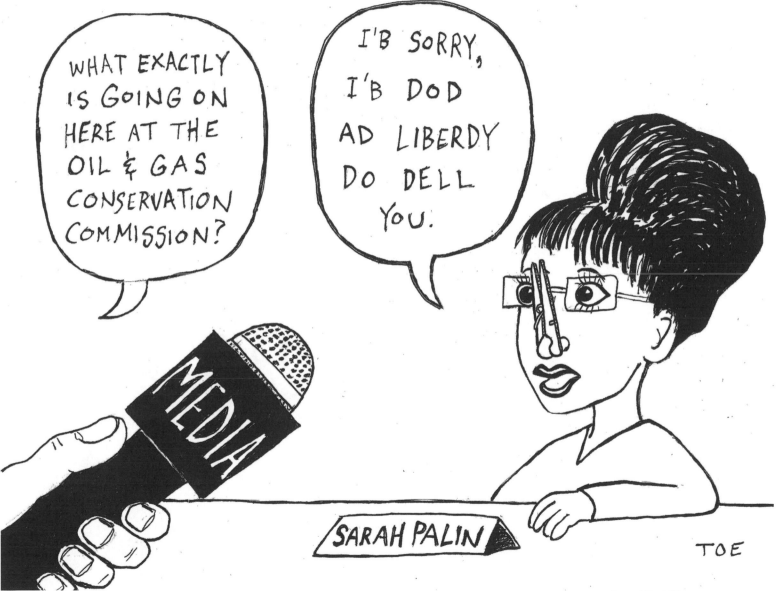

November, 2004

It's easy, given the current interest in Sarah Palin, to make a bigger deal out of this now than it was to Alaskans then. While Sarah did emerge from the scandal as a champion of clean, ethical government, the issue quickly faded after a few headlines and talk-show conversations. Randy Ruedrich remained chair of the Alaska Republican party; no public policy was changed to better prevent such ethical lapses; nobody in the Murkowski administration claimed responsibility for the matter taking so long to be resolved. The existing power structure for the state government remained in place and Sarah had clearly made enemies with the members of it. She was out of a job and, for all any of us knew (if we cared), out of politics.

CAMPAIGN FOR GOVERNOR

December 2003

Eventually Frank Murkowski, the Alaska Republican Party, and the oil industry would be victims of their own hubris.

Murkowski's downfall began almost from the moment he took office. In December 2002 he appointed his own daughter as his successor to the U.S. Senate seat he'd just left. The appointment was entirely legal but stunk of nepotism. He proceeded to make decisions that frustrated an astonishing variety of constituencies. Though he campaigned on a "no new taxes" pledge, he proposed a variety of "user fees" that sure looked like taxes. He dismantled the retirement pension system for state, municipal, and school district staff, earning the enmity of public employees all over Alaska. He phased out a "Longevity Bonus" program that provided a welfare check for every senior citizen in the state. He allowed hunting of wolves from airplanes, driving animal-rights activists crazy. He recommended funding cuts for a variety of government programs and cut off the "revenue sharing" grants the state provided to Alaska's towns and villages. Causing particular pain to those of us in Juneau, he moved several dozen Juneau-based positions in the state's ferry program to Ketchikan, forcing friends and neighbors to leave town or lose their jobs. Most famously of all, he sought the Legislature's approval to purchase a private jet. When the Legislature rejected the proposal he went ahead and purchased one anyway with state dollars—for $2.7 million.

To be fair, Murkowski believed he was working in the state's best interest. He was driven by a desire to get the state's fiscal house in order and had the misfortune to govern during a time of relatively low oil prices, which translated to a recurrent fiscal gap plugged by an ever-dwindling rainy day fund. But his brusque, condescending manner toward the Legislature and others whose help he needed, plus his sense of privilege, opened the door to challengers, including those in his own party.

Nowhere was Murkowski's haughtiness more obvious than in his approach to working with the state's major oil producers to build a natural gas pipeline and revise the way the state taxed them.

A gas pipeline has been a dream of Alaskans ever since the 1960s, when oil exploration on the North Slope revealed the ground contained vast reserves of natural gas as well. Unlike oil, however, the economics of a gas pipeline have never panned out—the gas has been too difficult to extract, too difficult to ship, and wouldn't return enough of a profit. As oil production on the slope continued its decline, the state began to get serious about developing this alternative resource. Murkowski took it upon himself to meet privately with Alaska's Big Three Oil companies, Exxon Mobil, BP, and ConocoPhillips to draw up a plan, and dismiss proposals by others.

Murkowski and Big Oil negotiated throughout 2005. When pressed for details Murkowski would insist the negotiations were too complex to explain and required the utmost confidentiality to be successful. On February 21, 2006 he announced that he had reached agreement with the oil companies on a plan for the pipeline and a new tax structure. To Murkowski's supporters, the plan was the best hope of spurring investment in Alaska, limiting short-term returns to the state but improving the chances the pipeline would actually be built and generate long-term revenue. To Murkowski's critics it was a bargain-basement sell-off that limited the state's flexibility to tax producers, failed to provide other assurances, and was entirely suspicious because it was developed in secret. At this point in the governor's term, he had a lot more critics than supporters.

A critical piece of Murkowski's pipeline plan was the promise it held for increased taxes on the oil companies. Alaskans, even the most conservative among us, had known for a while that the taxes imposed on the oil industry needed to increase. The tax structure basically hadn't changed for decades, even as Alaska became a more and more profitable place to do business. Democrats in the Legislature had long advocated for significant changes to the way oil companies were taxed, and Murkowski himself introduced a proposal to increase taxes on oil production in early 2005. That talk faded as it became clear he was working closely with the oil companies on a gasline proposal and with it a new tax structure. The plan he released along with his pipeline plan increased taxes, but wasn't nearly as hard on the oil producers as anyone expected. Murkowski proposed a tax rate lower than even his own consultant recommended. Moreover, the plan would keep oil companies at this same low tax rate for a guaranteed 30 years. Murkowski argued this guarantee was needed to provide the oil companies the assurance that Alaska would remain a friendly place to do business, and worth the risks and long-term investments that this huge project would require.

Oil taxes are a complex subject, and most Alaskans can't take the time to understand the arcane details behind what's good and effective policy. Instead, we elect our politicians with the expectation that they will learn these details and act sensibly on those decisions for us. Sometimes their failure to do so breaks through the carefully controlled press releases and testimonials in the Capitol, and we grow mistrustful. So it was with Murkowski. When a leaked memo revealed that his own natural resources commissioner questioned the legality of his plans, and Murkowski fired him, and then six high-level administrators walked off the job, we suspected that he had overreached with this proposal just as he had overreached with the jet, his Senate seat, and all the rest of it.

In May 2005 a national poll had revealed that Governor Murkowski was the second-least popular governor in the United States. By October of 2005 —more than a year before the next election— a number of individuals seized on this unpopularity and expressed interest in replacing him, including a few Republicans.

Sarah Palin was one of them. Even though she'd campaigned for him just a few years earlier, it didn't matter to her whether or not Murkowski might run to retain his seat. She said: "It's a wide-open race. I wanted to jump in there instead of first waiting for others to jockey into position."

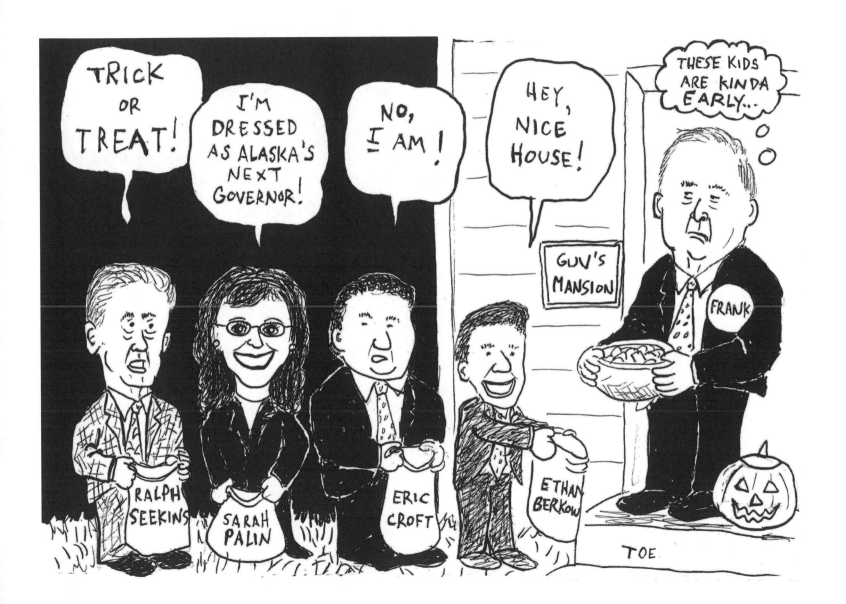

May, 2006

As the legislative session neared its end Murkowski's gasline proposal was going nowhere. Arguments about the best way to reform taxes on the oil industry were bogged down by their complexity and the uncertainties regarding the price of oil and the costs to drill for it. The governor had to call the Legislature back to Juneau for a special session to try and bring about some movement on these issues, and seemed determined to make progress on them. Given his unpopularity, the lack of progress on his agenda, and the lack of fun he seemed to be having, we were surprised when he announced late that month that he was indeed going to run for a second term. "We've got the momentum, and I want to see it through," he said.

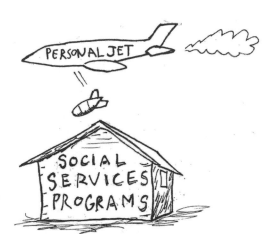

I'M RUNNING FOR RE-ELECTION 'CAUSE THERE'S SO MUCH MORE I WANT TO ACCOMPLISH!

TOE

By the time Governor Murkowski announced his intention to run for re-election his announced opponents included: Republican Sarah Palin, proudly wearing her whistleblower mantle; Republican John Binkley, a well-funded businessman and former legislator from Alaska's Interior; and Andrew Halcro, a former legislator, newspaper columnist, and car-rental chain owner from Anchorage. Halcro was a Republican but announced that he would be running as an Independent.

Two Democrats also declared their intention to run: Eric Croft and Ethan Berkowitz, legislators from Anchorage. Tony Knowles, a Democrat who already served two terms as governor, had lost a bid for U.S. Senator against Lisa Murkowski, and seemed determined to remain in public office, was also rumored to be looking on from the sidelines, weighing a bid; and even Loren Leman, Governor Murkowski's very own lieutenant governor, was said to be entertaining a run against his boss.

As unpopular as Murkowski was, he still had the advantages of incumbency: campaign funding, a high profile, a known quantity. Moreover, he could argue accurately that—for better or worse—he had made more progress than anyone else in making a natural gas pipeline a reality. That progress and the strength of his relationship with the oil and gas producers were the centerpieces of his campaign.

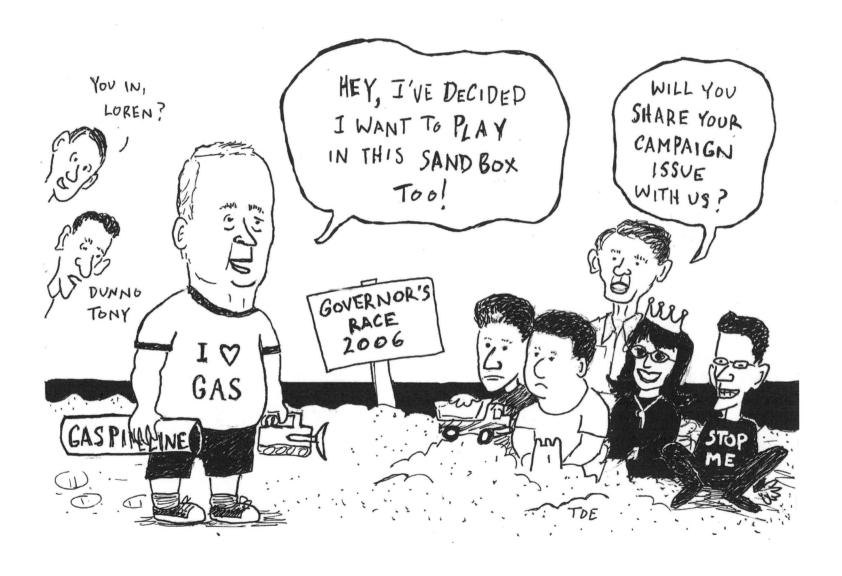

Former Governor Tony Knowles formally entered the campaign soon after Murkowski's announcement. His entry prompted Ethan Berkowitz to withdraw from the governor's race, endorse Knowles, and make a bid for the Democratic Party nominee for lieutenant governor. We all understood immediately that Knowles was the leading Democratic candidate. He was a familiar figure statewide and had a huge war chest left over from his previous runs at statewide office. Eric Croft did his best to distinguish himself as a "fresh face," but otherwise the two longtime family friends said nary a negative or challenging word about one another.

The Republican race, in contrast, quickly became heated. Conservative media personalities in Anchorage, standing by Murkowski, uncovered evidence that Sarah, while still mayor of Wasilla, had held meetings and used office email in the early stages of her campaign for lieutenant governor, and so really wasn't the ethical knight in shining armor she said she was. Murkowski and Palin campaign supporters jostled with each other at a Republican picnic in August. But Sarah remained above it all. In a televised debate she was demure and calm while Murkowski and Binkley bludgeoned each other over the details of the gas pipeline, oil taxes, and the state budget. In candidate forums she was non-committal about her position on a range of issues, readily admitting that she didn't always know the answers or the details, but that her regard for Alaskans, the Constitution, and freedom would guide her in leadership. The more closely anyone—including reporters—pressed her for specifics, the more they came off as bullies and old-guard polls interested in maintaining the status quo.

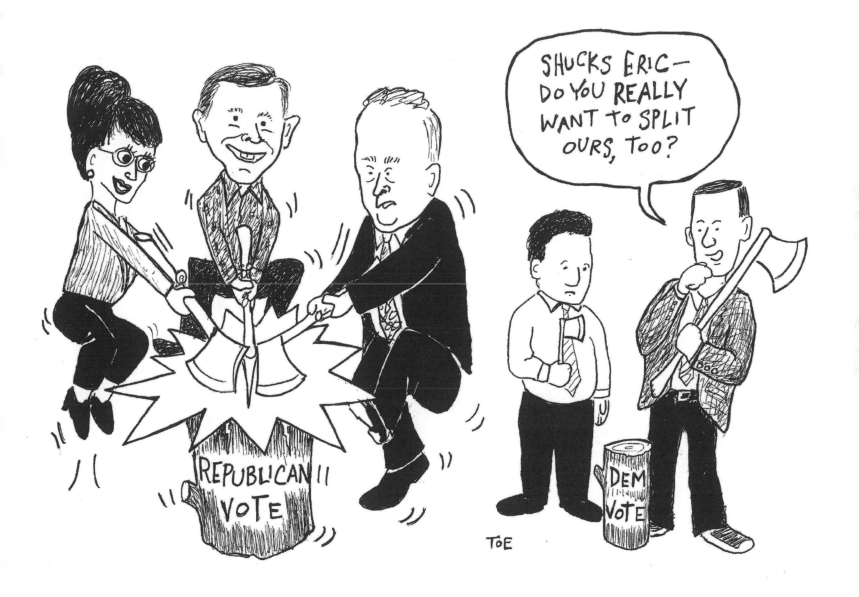

July, 2006

As it became clear that Sarah was going to be a real contender in the Republican primary this time around, Juneau re-opened her record and statements regarding Juneau's role as the state capital. Her opponents seized on our concerns, writing letters to the newspaper and suggesting that support for her would endanger our economy. Sarah took out an ad in the *Juneau Empire* and, under the title "Straight Talk on Alaska's Capital," wrote: "I support keeping the star on the map in Juneau, designating it as our capital city." Juneau residents spotted this as a dodge immediately, carefully crafted language that looked reassuring at first glance, but which sidestepped a real commitment to keeping the capital where it is. (We wondered why she couldn't just say, "I do not support moving the capital and will veto any attempt by the Legislature to do so.") Juneau's Republicans would have none of it, giving her third place in the primary in both of Juneau's election districts.

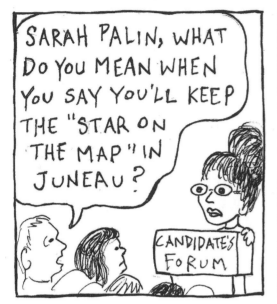

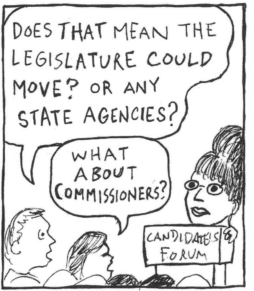

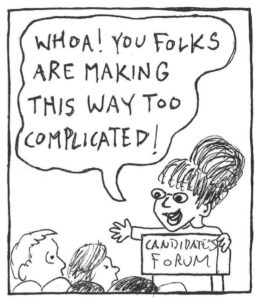

August, 2006

Statewide results were a much different story. Sarah won, Murkowski was crushed and John Binkley came in second despite having raised well over a million dollars, almost twice as much as Palin's and Murkowski's combined totals. Asked about the general election ahead against former Governor Tony Knowles, Sarah asked the *Anchorage Daily News*: "Are Alaskans ready to look forward to new leadership, or do they feel they need to look backward?"

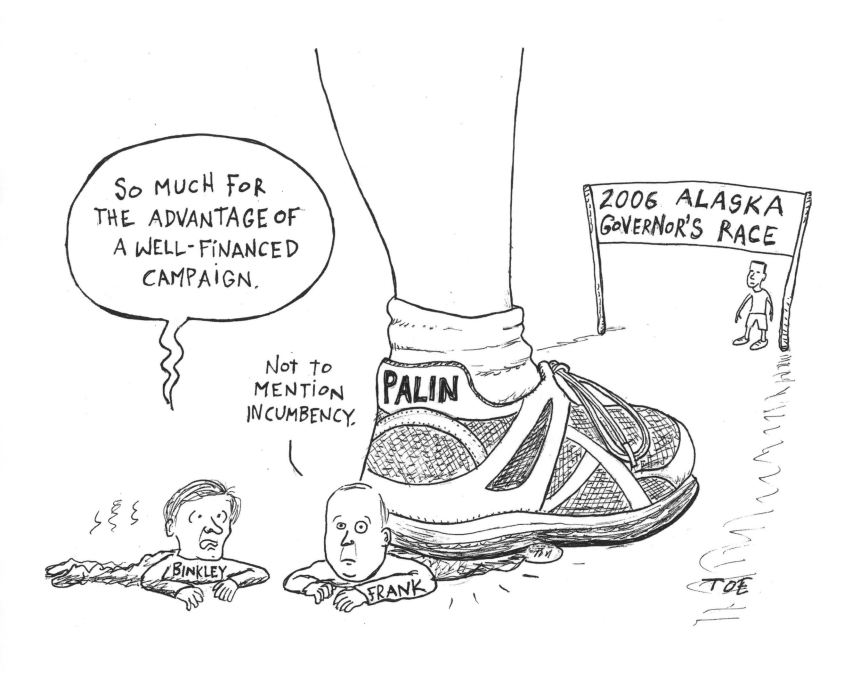

Right before the primary election in August 2006 our attention was momentarily diverted by news from the North Slope. The oil giant BP was shutting down half the production from the Prudhoe Bay field after an analysis revealed extensive corrosion and leaking in its pipeline. Earlier that year the company had spilled more than 5,000 barrels at another point in its pipeline, a leak also later found to be due to corrosion. We added the lack of oversight and maintenance that might have prevented the spill and shutdown to the list of things to blame on Frank Murkowski.

A little over a week *after* the primary our attention was diverted once more, this time by news closer to home: FBI agents with search warrants raided the Capitol in Juneau, emerging with box after box of documents. The search warrants showed that the agents were looking for documents establishing whether payments had been made to lawmakers by executives of VECO, an oil-services company in Anchorage, and whether any payments were at all related to legislators' actions regarding Murkowski's new oil tax plan, which the Legislature had approved earlier in August and which Governor Murkowski was preparing to sign.

Over the next several weeks Alaskans would feel very much in the dark about what this was all about. We didn't know who was being investigated for what, and how far the investigation would go. What we did sense was that we'd let the oil industry's influence penetrate too deeply into our politics. The time was right for the emergence of a politician who could demonstrate a resistance to that influence.

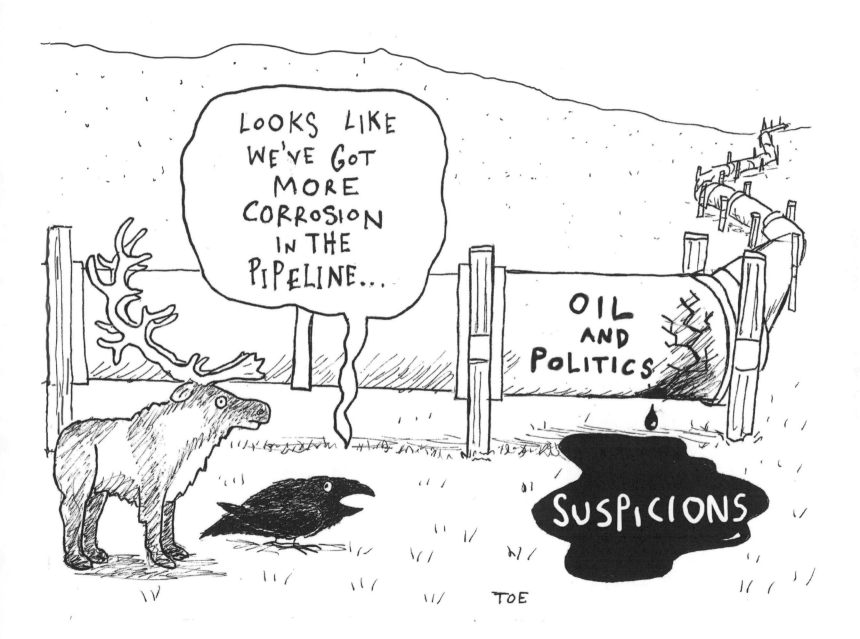

Tucked into the search warrants that gave the FBI agents permission to raid the Capitol building for documents was an odd mention that they also should be on the lookout for garments and hats bearing the name, "Corrupt Bastards Club" or "CBC."

The "Club" turned out to exist as little more than a joke among a few legislators who shared something in common: they'd been identified in a newspaper opinion piece for having accepted major contributions from VECO, the oil services company that was at the center of the federal investigation. Accepting major contributions from a corporation is not, in and of itself, a crime, and the legislators' joke was intended to highlight that fact. But as the mystery surrounding the FBI raids deepened and Alaskans' suspicions grew, we became angry at the carelessness and lack of statesmanship on display in the Capitol. Our elected officials, whom many of us already thought of as a group of rowdy schoolboys, were looking more like juvenile delinquents.

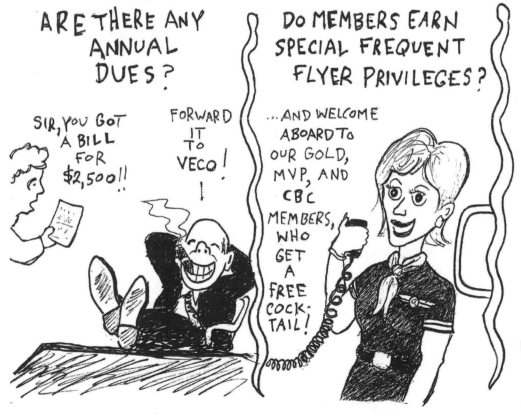

Meanwhile, the post-primary contest for governor was underway. The central campaign question: which candidate was best able to bring a natural gas pipeline to construction? Palin was endorsed by Tom Irwin, the natural resources commissioner that Governor Murkowski had fired. Tony Knowles received support from a wider range of oil industry and other business leaders. The two candidates sparred over who was truly being supported by Alaskans, but it turned out both of them were receiving sizable donations from both in-state and outside sources. Knowles raised significantly more money than Palin, but polls repeatedly showed her in the lead. As October proceeded Knowles stepped up his direct criticisms of Sarah for her lack of experience and specifics on the gas pipeline issue. There was no shortage of clichés being offered by either candidate.

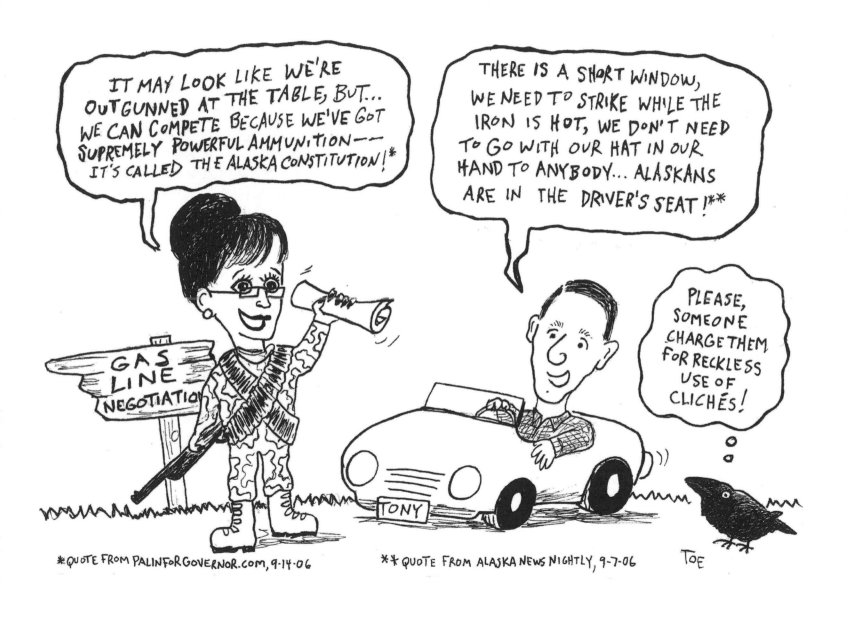

*QUOTE FROM PALINFORGOVERNOR.COM, 9-14-06

**QUOTE FROM ALASKA NEWS NIGHTLY, 9-7-06

Another Halloween; another political campaign in its end stages. Still in the race alongside Sarah Palin and Tony Knowles was Andrew Halcro, the former Republican legislator now running as an Independent. An intelligent, thoughtful communicator, Halcro did more than anyone to draw Sarah Palin into the open and question her knowledge about campaign issues. He debated effectively with her and Knowles, and ran funny campaign ads ("Stop Me!" "Don't Be Afraid!") that ribbed himself and the fighting between Democrats and Republicans. He sought to tap the large number of Alaskan voters not represented by any political party, urging them to take a chance on him. But without party backing his campaign struggled. The question in the home stretch was not whether he would win, but whether he would take enough votes away from Sarah Palin to give Tony Knowles an unexpected victory.

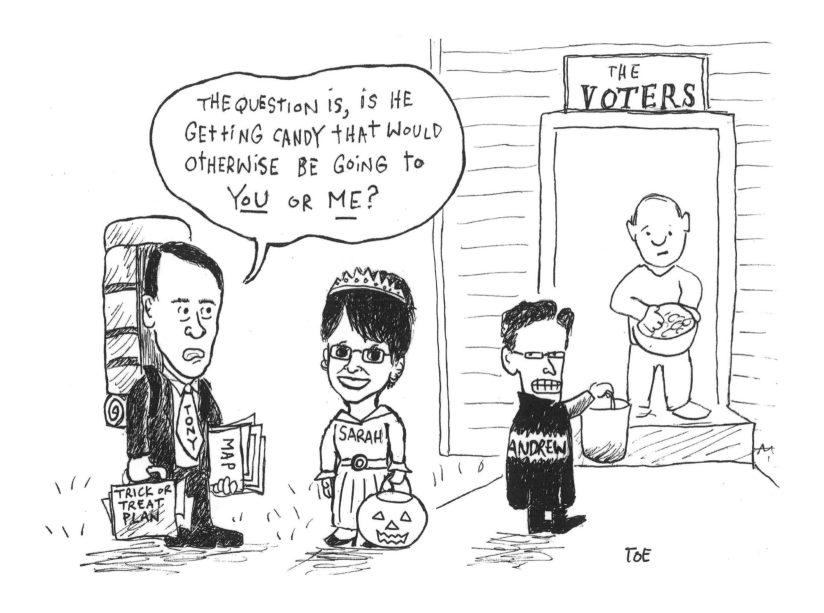

As the campaign entered its final days Sarah Palin was a main topic of conversation over the dinner table, on hikes, at the bar, around the coffee maker. But instead of asking what she was proposing to do about a natural gas pipeline, or health care reform, or where, exactly, she stood on abortion or teaching creationism in school, one question came up more than any other:

Is Sarah Palin sexy?

The answer could pretty well be predicted along the lines of how Alaskans intended to vote—and whether they were men or women. Liberal women could grant she was striking, but in an overdone, tacky kind of way. Conservative women looked at her obvious ease with her family and her religious beliefs and saw someone who could be both playful and faithful. Men of all political persuasions saw a woman they wouldn't mind having along on a hunt (conservatives) or a hike (liberals), and both could imagine the day ending with a cleansing swim in an alpine lake, a spirited night in a two-person tent.

So, my friends Jana and Barb wanted to know what it is about MEN and SARAH PALIN...

What's the attraction, anyway?

I just don't see it!

I assured them we KNOW her appearance is carefully crafted to convey a sense of her as PRIM, SERIOUS... ...AND MATURE!

Her staunch conservatism appeals to those men comfortable around strict moms and teachers.

You've been thinking of supporting an income tax, haven't you?

Yes! I've been bad! Spank me!

Other men may feel that her campaign prompts certain psychological respon—

Oh, cut the crap!

is she HOT or NOT?

I told them to picture her without the tiny glasses... her hair coming undone...

Then I had to get some fresh air.

But I did point out that not all men may feel this way...

What's her attraction, Andrew?

I just don't see it, Tony!

POLLS

TOE

In their televised debates, Sarah Palin appeared fresh and bright-eyed; next to her, Tony Knowles— an otherwise fit and handsome man—looked gaunt and enervated, even as he had better command of the issues. In the end, 8% more Alaskan voters took a chance on fresh and bright-eyed. Sarah Palin was the first female governor of Alaska and the first governor born after statehood. There'd be more firsts before she was done.

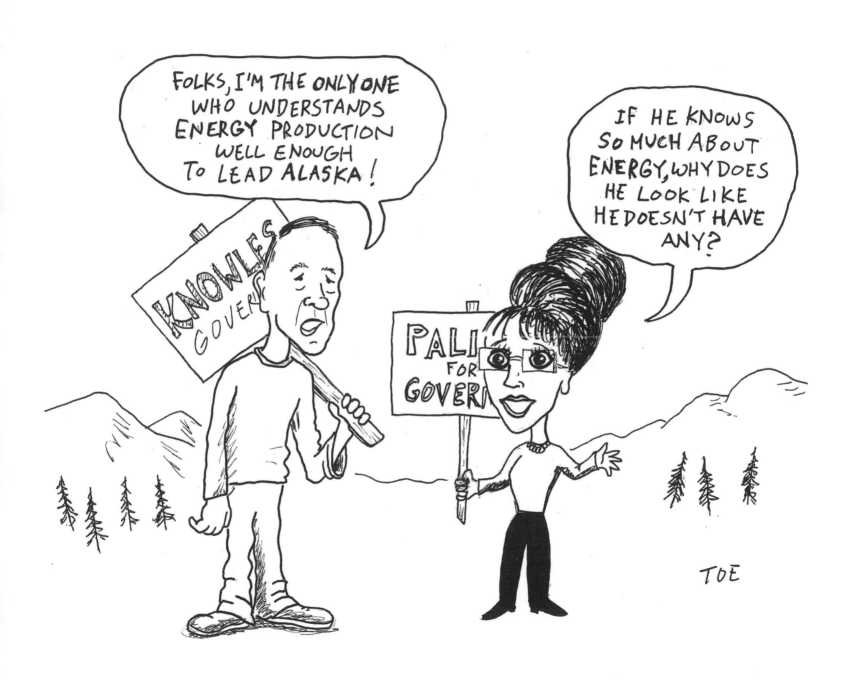

GOVERNOR – PART I

December, 2006

Sarah Palin held her inauguration ceremony at the convention center in Fairbanks, the first time an inauguration for governor was held outside of Juneau. This prompted some momentary anxiety here. Juneau hadn't exactly come out for Sarah Palin on Election Day—Knowles beat her with almost three times as many votes here—and so we wondered whether her change of venue was an intentional snub and a sign of things to come. But then we learned that she selected Fairbanks in recognition of its role as site of the state's constitutional convention, 50 years earlier, and we immediately forgave her. Her inaugural address hit all the right notes about Alaska's promise and the character of our citizens, and she presented them with humility and grace. So what if she did it from Fairbanks? Surely she would be open to and supportive of Juneau once she arrived here, just like every governor before her.

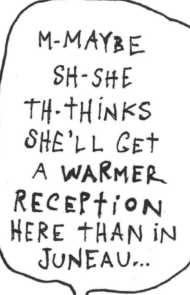
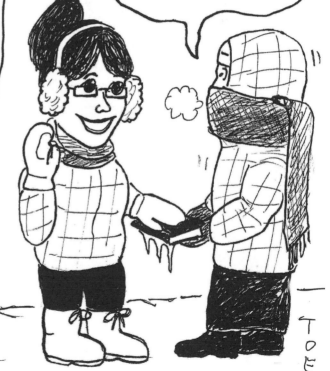

December, 2006

When Sarah Palin came to town a month had gone by since she was elected. In that time she revealed that she would not require her cabinet members to live in Juneau—decisively bad

news to us. Was she dragging her feet in coming herself? The *Juneau Empire*'s excellent political reporter, Pat Forgey, noted that the Governor's House was in the heart of a voting district in which she had fared especially badly. "In fact, if she walks downtown, she can count on less than one in every 10 people she sees as a supporter," he wrote.

Nevertheless, Juneau's mayor was determined to make her feel welcome when she finally did arrive. Bruce Botelho called for Juneauites to rally around the Capitol intersection at 4th Street and Main to cheer for Sarah as she drove by, on the way to her new residence. And Sarah was reported to be gracious and upbeat as she settled in over the next few days, walking around town in spite of the cold weather, thanking and shaking hands with the Juneau residents who welcomed her.

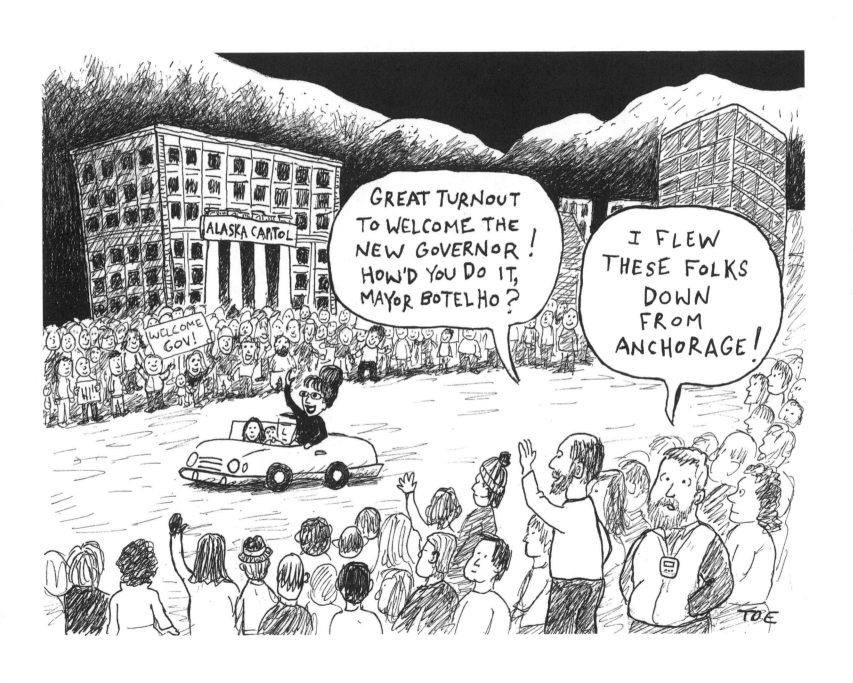

When Sarah Palin came to town it made some of us think of what life might have been like in Washington DC when the elegant young Kennedys moved into the White House after those geriatric, Midwestern Eisenhowers. But the Palins gave everything a distinctly Alaskan spin. Here was a successful, fit young family, as at-home in the Bush as in elegant receptions; the strong, silent, handsome husband, taking time away from his snow machine contests, fishing trips, and oil-field work to put on a jacket and tie, standing by his wife with his flinty eyes and occasional flash of cowboy smile when she called him the "First Dude." Here were her children, Bristol, Willow, and Piper, their names gathered from the Alaskan landscape like berries, so clearly their mother's daughters, but each a different take on her personality and looks. (We knew virtually nothing about Track, where he was or where his name came from. Still don't.)

And here was Sarah Palin herself: unassuming and eloquent at her inauguration in Fairbanks, approachable and friendly as she took up residence at the mansion. She welcomed Juneau residents into her home for her first annual open house, and was poised, warm, and beautiful throughout the evening. Teenagers knocked on the Governor's House door later, she invited them in, and we talked about it for days. We held an inaugural ball to toast her arrival and she arrived looking like a knock-out; but when we asked her who designed her gown she giggled and said for all she knew, the dress was made by Carhartt. We swooned with pleasure. At the same time that we laughed off the idea of anything in Alaska having any kind of glamour we also lapped up the suggestion. For we saw in Sarah Palin what we Alaskans like most about ourselves, or at least like to think about ourselves: that we are independent but always ready to pitch in to help a neighbor or our community; principled, but able to give and take a joke; ready and prepared for whatever the elements and fate are prepared to dish out; and that underneath our winter coats, flannel shirts, long underwear and pale skins we are interesting, attractive, and yes, even sexy, in an unpolished, outdoorsy, come-explore-my-last-frontier kind of way.

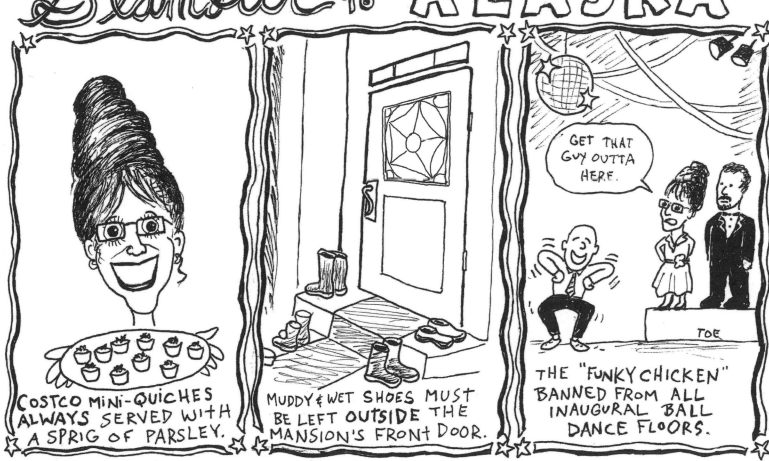

December, 2006

She announced that she was selling off Governor Murkowski's despised jet, just as she'd promised she'd do during her campaign. It started out for sale on eBay, and though it was ultimately sold to a private purchaser in Alaska, and not through eBay at all, this amusing little detail—that she had even *tried* to sell it alongside the old bicycles and exercise equipment *we* were trying to sell, bypassing the usual government bureaucracy required to do such things—endeared her to us all the more.

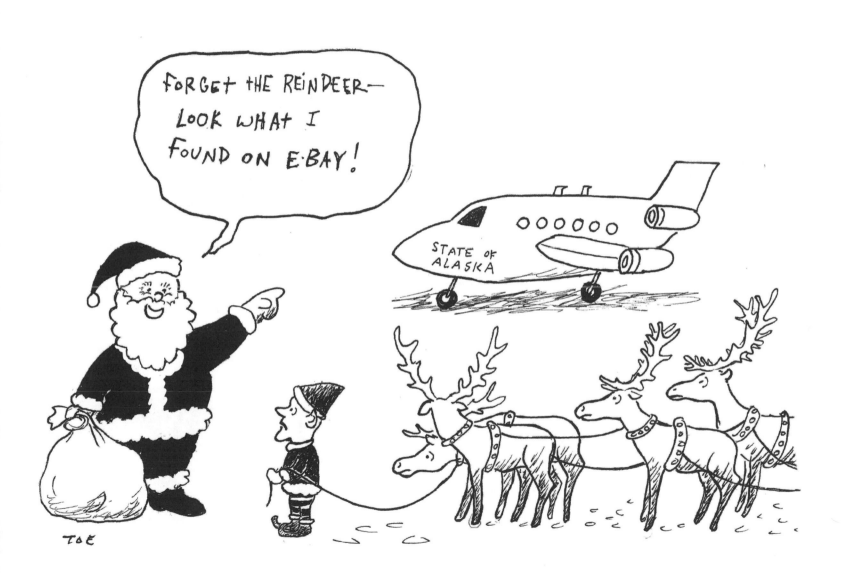

Indeed, as Governor Palin set to work, her primary objective seemed to be undoing the previous governor's legacy. In addition to the jet sale, she announced that she would cancel the contract for the "Pioneer Road," the gravel road that would be the first step in building a road from Juneau to Skagway. She said she found the plan incomplete and questioned the transparency of the procurement process used to develop the contract. She took hold of the preliminary budget assembled by Murkowski before he left office, saying that although she intended to cut it by $150 million, she would restore the Longevity Bonus program. She dropped Murkowski's appointment of his son-in-law to the Alaska Railroad Commission, which he'd done in the last hours of his administration. And she signed a bill into law to require the governor and the state's Board of Parole ensure that decisions to offer clemency to convicted criminals included consideration of the victim's needs. The bill was a response to a pardon Murkowski had made to a company convicted of criminally negligent homicide for the death of one of its employees. No one from his administration notified the victim's family about the request for clemency, or notified the victim's family that the pardon was granted.

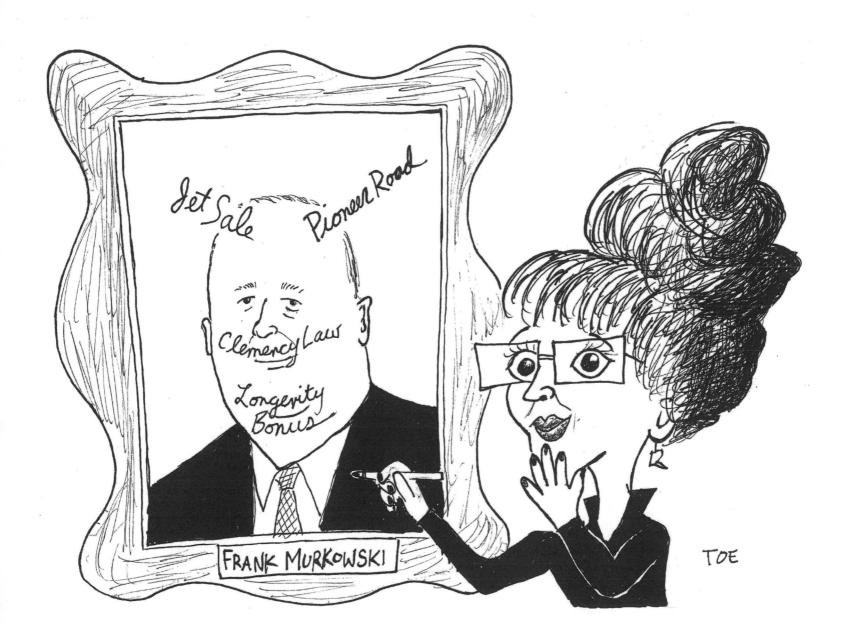

But the one legacy that Governor Palin wanted to undo above all others was Murkowski's gasline proposal. At her first State of the State address she made clear she was abandoning his old plan, which the Legislature had hated, and was going to start over with a more open, competitive process—"something like a request for proposals," as Representative John Coghill of North Pole put it. She also promised to re-examine the Petroleum Profit Tax that had passed under Murkowski's watch and see if it was providing Alaskans the returns that had been forecast.

The legislative session would proceed to cook up the usual stew of education bills, crime bills, and health care bills; and in the continuing unfolding VECO scandal, there would be ethics bills to discuss and debate. But in her briefings and press conferences Sarah Palin clearly was focused on seeing that attention was primarily being paid to the gas line and oil taxes. And she made it clear it was more important to her that the work get done transparently than quickly.

March, 2007

The first 100 days of the administration of Sarah Palin and Sean Parnell (her lieutenant governor) went smoothly. Several lawmakers remarked to the media that the relationship between the new administration and the Legislature was off to a great start, and much improved over the previous administration. She scored a 73% approval rating from Alaskans in a poll, and for a long while her approval rating would only go up.

By the mid-point of the legislative session the only bump that had occurred was some disagreement over the details in the ethics bills floating around the Capitol. Palin, House members, and senators all introduced ethics bills. Senator Hollis French, a Democrat who had defended and complimented Palin's actions when she left the Oil & Gas Conservation Commission, had a bill moving faster than any other, but Palin didn't like it, saying that it wasn't strong enough in preventing legislators from accepting gifts from lobbyists. Her proposed amendments were rejected by the Senate and the bill passed over to the House despite her objections. In the end, a couple of ethics bills passed during the session. Both the governor and legislators cited them as examples of the good bipartisan cooperation and working relationships that existed in the Capitol.

Once legislators and oil producers got a look at Palin's Alaska Gasline Inducement Act (AGIA) proposal, however, debate over ethics reform was mild in comparison.

While Murkowski had negotiated his pipeline deal exclusively with Exxon Mobil Corp., ConocoPhillips and BP, Palin opened the project to any group interested in the project, not just the Big Three oil companies. She sweetened the possibility that other, smaller companies could participate by offering up to $500 million from state coffers as a way to prime interest and make startup costs more affordable. Palin's proposal also promised only 10 years of unchanged tax rates on producers (compared with Murkowski's 30 years), and the project would have to obey state timelines, not whatever the winning company proposed.

It took a couple of weeks for the Big Oil companies and legislators to analyze the proposal, and when they finished they had plenty to say. Legislators questioned a number of provisions about the bill—their role in approving a final contract, the timelines for that approval, and the details on how a winning proposal would be selected and coordinated. But they began work on these provisions with great confidence these concerns could be successfully addressed. The oil companies were less hopeful. Exxon and BP executives said the plan asked them to assume too much risk and made demands in places where it should have allowed negotiation. In public hearings executives from the Big Three said they liked the plan's competitive approach, but according to Governor Palin's staff they privately grumbled about this. AGIA invited other players into what they'd always seen as their own treasure trove of gas. Big Oil appeared to resent this shift in power away from them and toward the state.

Murkowski's plan would have maintained the status quo that the oil companies were accustomed to. Governor Palin's plan was more popular with Alaskans, but without the cooperation of Big Oil, less likely to result in the construction of an actual pipeline. Murkowski's plan had died in the Legislature. Palin's gas line plan passed before the session adjourned.

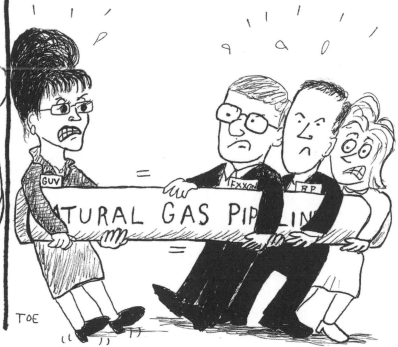

May, 2007

That spring a couple living outside Homer stepped on to their deck and watched a brown bear attack, rip open the chest cavity, and eat the heart of a full-grown moose on their driveway. They recorded the whole thing with a video camera and the event became a brief world-wide sensation on YouTube.

The moose-heart-eating bear video was a pleasant departure from the reasons Alaska was more typically making national headlines. The FBI raids of 2006 turned into the indictments and convictions of 2007. Two former representatives were arrested and charged with bribery, extortion, and wire and mail fraud; a third representative turned himself in for similar charges. A few days later two executives from the oil services firm VECO pleaded guilty to charges of extortion, bribery, and conspiracy.

Ultimately, of the six lawmakers who had their legislative offices searched, only one would *not* be implicated in the unfolding scandal. Moreover, there were hints that more indictments and convictions might be lurking out there, reaching the highest levels of Alaskan government.

Many of us knew these legislators well. Their kids went to school with our kids; they played on our sports teams, they responded kindly when we asked them to donate to our charitable causes. The corruption made us both angry and sad. And it lent even more strength and support to Governor Palin. She signed a sweeping ethics reform bill that summer, just minutes after the first legislators were convicted on corruption charges. Her approval rating among Alaskans climbed to 93%.

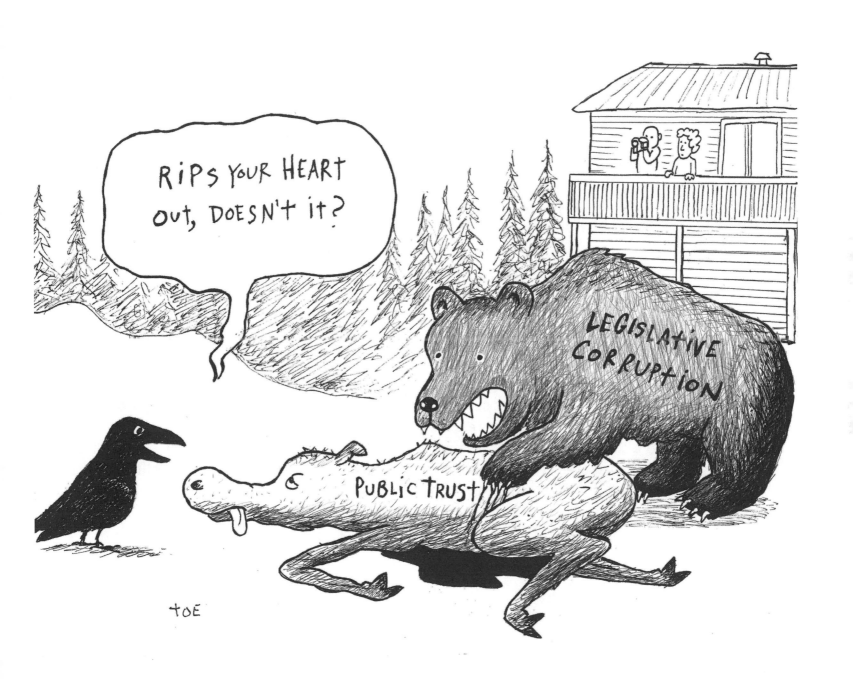

June, 2007

That summer the governor who campaigned as a hard-core fiscal conservative signed into law the largest operating budget in state history. She did make a number of cuts to the capital budget— vetoing a number of legislators' pet projects— but the operating budget is where government growth sticks, where money is very hard to get out once it gets in.

Around this time there was a brief kerfuffle over some happenings in Sarah's hometown. The Matanuska Maid Dairy, a state-owned business outside Wasilla, had long been unprofitable and in the spring of 2007 the Alaska Creamery Board, which oversaw the dairy, voted to close it down. Sarah requested that the dairy be kept open, and the Board rejected her request. Sarah offered to intervene and find a way to keep the dairy open and the Board rejected that overture as well. When she showed up one day requesting a tour of the Anchorage dairy, staff refused to admit her.

She got even: she replaced the entire membership of the Board of Agriculture, which oversaw the Creamery Board. The agriculture board voted to keep the dairy open for 90 days to review options. Ultimately, though, the dairy couldn't be saved. An earlier appropriation of $600,000 that was to pay for a review of operating expenses was allowed now to assist with the dairy's "transition" to a private owner. No private owner ever stepped forward and the dairy eventually closed down.

Watching Sarah Palin work so hard to save an ineffective government program in her home neighborhood reminded us of something she had said during the campaign for governor: "Certainly, people will assume that I'm biased toward the (Matanuska-Susitna) Valley in the decisions I make. So be it. Because I will be." (She later apologized for the comment.) We saw that, even with all her promises of ethical, transparent government, Sarah's politics could be personal.

The oil corruption scandal continued to unfold, and in Juneau we noticed a troubling usage creeping into Alaska's vernacular. The rest of the state wasn't just blaming particular politicians, lobbyists, or corporations for the mess; also at fault was Juneau itself. You could hear it in the venom with which they spoke: "Well, that's just *Juneau* for you." Juneau wasn't just a town; it was an attitude, a sketchy moral code, a corrupt frame of mind.

An even more worrisome development: Palin called for a special session to finish off the work legislators had begun on the state's senior assistance program. Legislative leaders responded by saying the session would be held in Anchorage—the first special session ever to be held outside of Juneau, and in spite of the Legislative Affairs Agency's finding that a special session in Anchorage would cost almost twice what it would cost in Juneau. Sarah maintained that it was the Legislature's decision, not hers, but we suspected she was fine, if not pleased, that the Legislature would meet closer to the friends, family, and voters she trusted.

WHAT'S THE **REAL** REASON FOR ALL THE CORRUPTION IN THE ALASKA LEGISLATURE?

ETHICAL LAPSES?

CHARACTER DEFICIENCIES!

UNCLEAR RULES!

CONFLICTS OF INTEREST?

NO. LEGISLATORS ARE CORRUPT BECAUSE OF WHERE THEY MEET.

WELCOME TO JUNEAU
LEAVE YOUR MORALS BEHIND!

CHECK OUT THE MAY 22 EDITION OF THE ANCHORAGE DAILY NEWS.

IN AN ESSAY ON THE EDITORIAL PAGE, AUTHOR JOHN STROHMEYER WRITES:

"OUR PROBLEM IS THE EVIL POLITICAL CULTURE THAT HAS FESTERED SO LONG IN JUNEAU."

"THE ONLY WAY TO FIX [IT]...IS TO TAKE THE LEGISLATURE OUT OF GOMORRAH."

OUCH TOE

AND **YOU** THOUGHT JUNEAU WAS JUST A SMALL TOWN FULL OF MOSTLY DECENT PEOPLE.

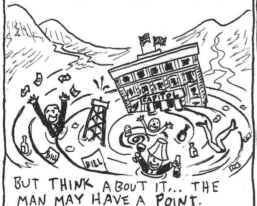

CAPITOL
BILL
BILL

BUT THINK ABOUT IT... THE MAN MAY HAVE A POINT.

LOOK AT NEW YORK STATE— ARE THE PARALLELS WITH ALASKA JUST *COINCIDENCE?*

A FEW MONTHS AGO, THAT STATE'S COMPTROLLER RESIGNED AMID ACCUSATIONS HE MISUSED HIS OFFICE. BUT...WAS **HE** REALLY GUILTY OF ANYTHING?

...OR IS ALBANY— NEW YORK'S SMALL, ISOLATED CAPITAL CITY—REALLY TO BLAME?

NEW YORK

ALBANY POP: SMALL

NEW YORK CITY POP: REAL BIG

NEXT: LET'S VISIT SOME OTHER POTENTIAL CESSPOOLS OF VICE: LITTLE MONTPELIER, VERMONT, AND ISOLATED PIERRE, SOUTH DAKOTA!

August, 2007

So Juneau was already feeling edgy about its status as the state capital when Sarah revealed that she and her family would be returning to Wasilla, and not making Juneau their home. We'd already had our suspicions that she wasn't taking to Juneau; the lights in the Governor's House were rarely lit; we almost never saw her children playing on the trampoline that had been set up on the Governor's Mansion yard; we never saw Piper swinging from the buoy swing that hung from the tree in the northeast corner of the yard. We learned that she had dismissed the chef who had worked for previous governors, and that the Palins had concerns about the physical condition of the House—windows needed to be restored, leaks needed to be repaired. We learned that her children would not be returning to Juneau's schools in the fall, and that she would live in her Wasilla home and commute to her office in Anchorage.

We had done our best to ignore her allowing her cabinet members to live wherever they chose. We had rationalized our way past the Legislature's special session in Anchorage—it was only a one-day session, after all. But it was no longer possible to ignore that the capital, the heart of our economy, was leaking away. A governor is the most visible and symbolic representation a state has. And we had identified the best of ourselves in Sarah Palin—the humility, the principles, the attractiveness—so now what did it mean if our best self no longer had any regard for our town? If she didn't need Juneau, did Alaska?

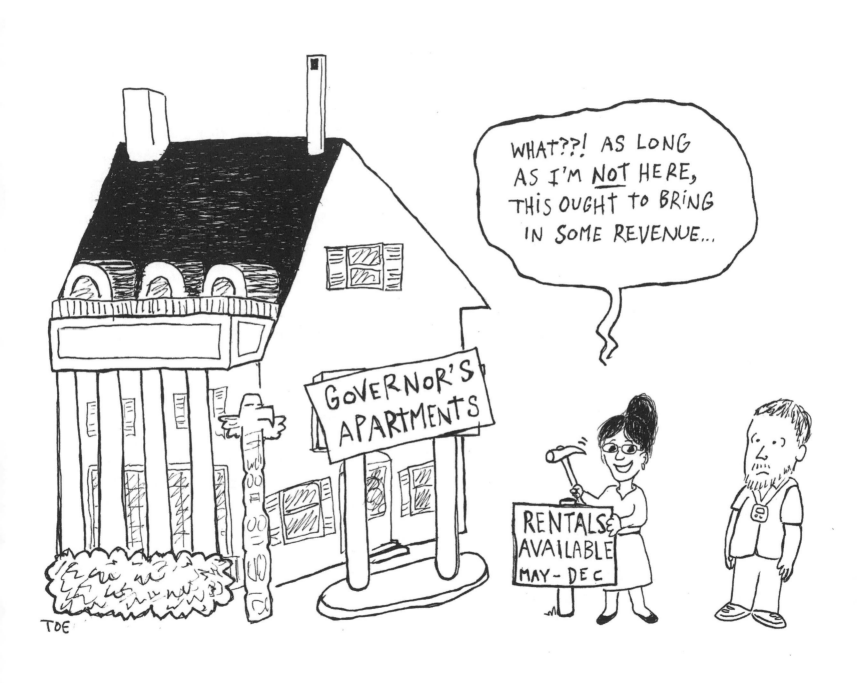

Other events that summer and fall contributed to the feeling that Governor Palin truly did have little regard for Juneau in particular and southeast Alaska in general.

First, she signed into law her first capital budget, vetoing about $230 million worth of projects proposed by legislators. The annual capital budget exercise is a state government tradition, with legislators typically asking for far more in projects than they expect to get. But this year—even though Governor Palin had campaigned as a fiscal conservative, and it shouldn't have been a surprise—legislators felt particularly stung by the cuts. They stated that they didn't get any guidance from the governor's office on how she would approach vetoes, and as it turned out just about everything was fair game. She cut nearly a quarter billion dollars from the state's budget with the use of her line-item veto, including more than $3.2 million in Juneau projects.

Second, Governor Palin decided to not move forward with the Gravina Island Bridge to Ketchikan, even though she had been vocal in her support for it during her campaign. Her press release said she was directing the department of transportation and public facilities to look for the most fiscally responsible alternative for access to the Ketchikan airport and Gravina Island, rather than the proposed $398 million bridge, which was starting to make national news as an example of wasteful earmark spending. But whatever jokes were floating around about the "Bridge to Nowhere," every southeast Alaskan who had stood in Ketchikan's driving rain, waiting for the airport ferry, knew the need for that bridge was no laughing matter.

Third, Governor Palin had begun talking about the need for another special session, this time to reconsider the petroleum tax that Governor Murkowski had put into place. Her spokeswoman said the governor preferred the session to be held in Anchorage or elsewhere on the road system. Juneau's legislative delegation held a meeting with Palin to try and get her to change her mind; and when House Speaker John Harris polled House members the vast majority agreed the special session should be in Juneau. A month would pass before she finally called the session to happen here, but even then she expressed the hope that committee meetings to accompany the session would be held elsewhere.

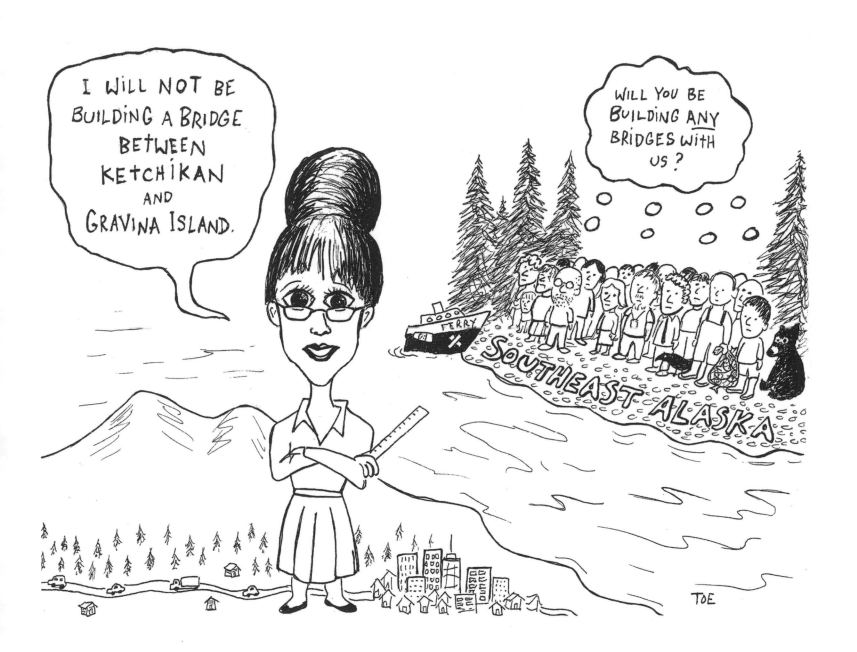

October, 2007

Governor Palin eventually polled Senate members, who, like their counterparts in the House, said they preferred that a special session to review Murkowski's Petroleum Profits Tax be held in Juneau. And so the Legislature met here during our rainiest month.

It was a glum session. The federal corruption probes had, by now, led to five convictions or guilty pleas by legislators or lobbyists. VECO executives admitted that they'd bribed or attempted to bribe additional legislators. And the federal corruption probe also ensnared Senator Ted Stevens, whose home in Alaska was raided and searched; and the air was thick with suspicions that still more indictments were coming down.

Governor Palin suggested that Murkowski's oil tax plan never would have passed the Legislature if not for the bribes and influence-peddling afoot in the Capitol the year before, and Alaskans suspected she was right. But even if every vote in favor of the tax was clean the tax still wasn't living up to its promise. A governor's report issued prior to the special session showed that Murkowski's tax brought in far less revenue than expected, did not spur the investments that were promised, and that oil companies were claiming twice as many deductions for their expenses as anyone expected. The state's balance sheet made it sensible for the Legislature to come together for a special session to address oil taxes, and so did the political barometry.

The Legislature, led by gangly Senator Lyda Green and compact House Speaker John Harris, launched into dizzyingly complex arguments over oil taxes with Governor Palin's advisers. A few of the issues in question: whether to tax the oil companies based on their gross or net profits; how to get a fair share of the wealth for Alaska when oil prices—and, as a result, corporate profits—are really high; and, especially, how to determine an appropriate tax rate.

House and Senate committees working on Governor Palin's plan gutted the provision that would have raised the net tax rate from 22.5% to 25%, then returned those provisions in later committee hearings; then cut it back again to 22.5%; oil executives testified against any increase; legislators coined the word "bumfuzzled" to describe their reactions to the bill's complexity. Two senators—one a Republican and one a Democrat—walked out of a hearing when Exxon refused to disclose its profits; an oil company gave a speech on Wall Street accusing Alaska of having changed its taxes a dozen times in recent years, saying these changes rendered it impossible to do predictable business here. The Alaska House of Representatives finally approved a 25% tax rate and the Senate followed.

Governor Palin left almost all the heavy work of explaining and advocating for her bill to her advisers, prompting some legislators to question whether she understood the bill at all.

Rather than take the bait she said she was going to "stay above that fray."

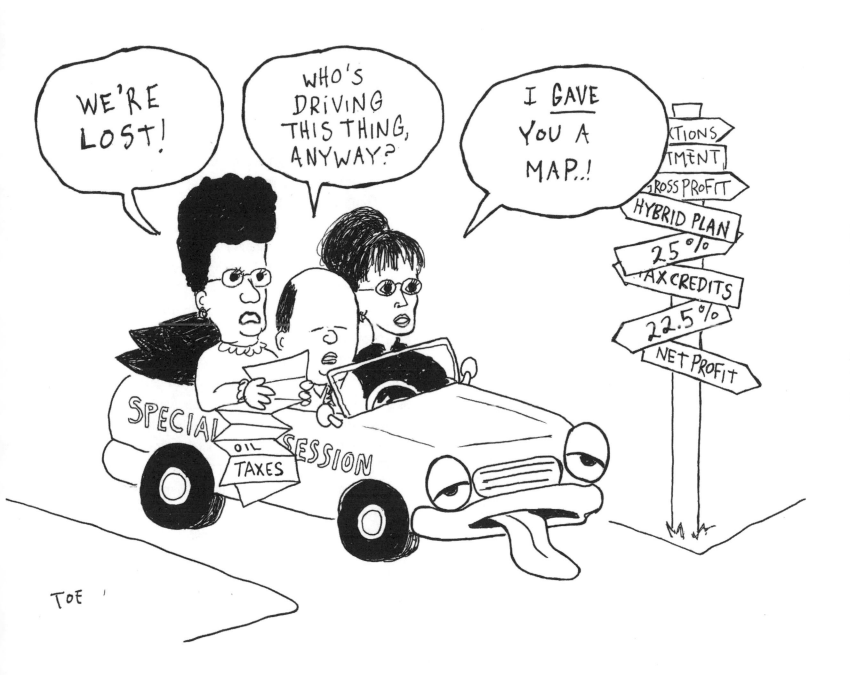

The oil industry pulled out all the stops to prevent a tax increase. Oil field workers, company suppliers, contractors, and executives sat before microphones and testified that a tax hike would dramatically decrease investment and hit their incomes hard. They complained that frequent changes in tax rates were making Alaska as unpredictable a place to do business as a third-world nation, even though Alaska had in fact only changed oil taxes twice in a quarter century. At one point, BP stated that Alaska's department of revenue had illegally released confidential information about taxes the company paid, but was unable to provide information to back up its accusations. Another time, Exxon said it believed the existing taxes were already too high and needed to be *lowered*—which wasn't on anybody's radar.

It didn't help Big Oil's case that it was also refusing to let Alaskans heal an old wound. Exxon still refused to pay the punitive damages owed to the fishermen, business owners, cannery workers, and others harmed by the Exxon *Valdez* oil spill, 18 years earlier, still arguing in court that the company had already paid enough when it helped clean up the spill. While the special session was under-way Exxon was gearing up for its appeal to the U.S. Supreme Court, and the state was once again going to bat for the victims.

Ultimately, though, the oil companies' biggest weakness was their very strength: they continued to pull in massive profits in Alaska. In 2006 ConocoPhillips reported revenues of $6.3 billion from Alaska, BP reported $6 billion. More and more, their protests about higher taxes being unfair and harmful made them appear disconnected from reality and how they appeared to others.

An oil industry making huge profits and playing fast and loose with facts; a Legislature crippled by allegations of corruption; a governor standing firm and focused, and with the vast majority of Alaskans behind her. The Legislature passed her bill pretty much in the form she'd given it to them. What's striking in reviewing the votes is to see that Sarah had done it by uniting the Democrats in both Houses with a curious mix of Republicans—hardcore conservatives as well as moderates. Sarah Palin succeeded in her first major test as governor by being a thick-skinned unifier.

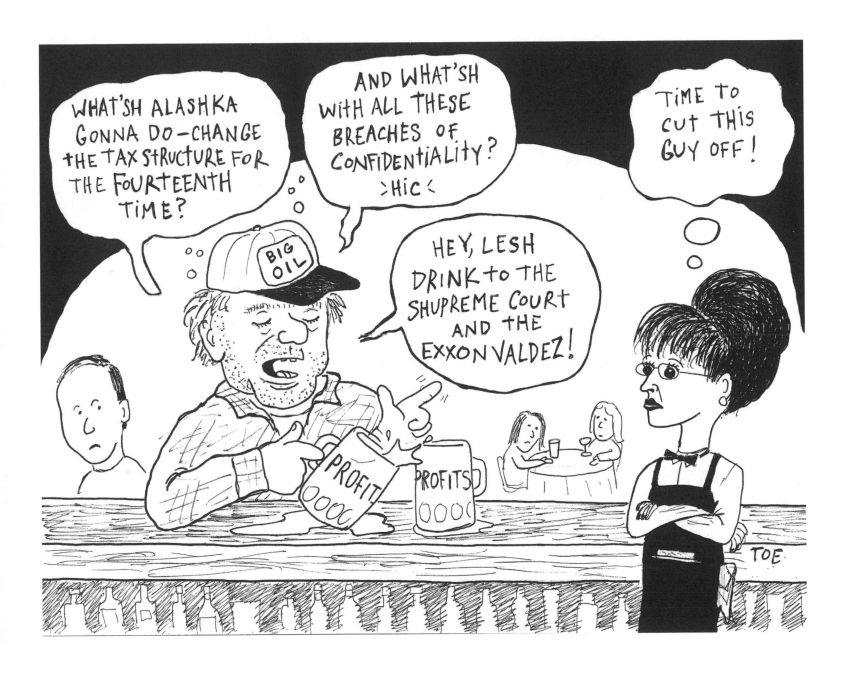

December, 2007

Alaska's legislators departed after the special session, and so did Governor Palin. In Juneau, while we could understand and congratulate her success with her bill, we looked gloomily toward the abandoned Governor's House—festooned with Christmas lights and garland, but its windows dark, its shades drawn. Would she and her family return for the annual Open House reception, one of Juneau's favorite holiday traditions? It turned out they would. But the Open House had the feel of a perfunctory exercise rather than a true welcoming of her neighbors into her home. She may as well have invited us to visit her at a hotel. We waited in line, listened to the carolers, entered the front door, and shook the Palins' hands in the grand foyer, and it felt like they were the visitors, not us.

Word of Governor Palin's successes and popularity was starting to extend beyond Alaska's shores and tundra. An oddball web site or two had even begun touting her potential as a politician of national significance; and then in late 2007 a widely distributed Associated Press article noted that Palin, "a female reformer," could help the national Republican Party break its image as a group of "wrinkled old white men taking cash under the table."

Her appeal might have been obvious to us, but we really didn't give the nationwide attention much serious thought. Alaska was too remote, too unusual in too many ways. While most other states were struggling with budget deficits, we packed away money into savings accounts. While most other states were cutting services, we passed the biggest operating budget in state history. While most other states contemplated raising taxes, we continued to write ourselves checks every year—a thousand dollars or so for every man, woman, and child through our Permanent Fund Dividend. Sarah might be representative of Alaska at its best, but *the whole country*?

A few weeks after the New Year began the 25th Alaska Legislature convened in Juneau for its second year. But now it met under a new constraint. Back in 2006—in the same election in which we'd elected Sarah Palin governor—Alaskans approved a ballot measure to limit legislative sessions to 90 days instead of the traditional—and still constitutionally permitted—120 days. The measure was driven by a few legislators from the north that somehow convinced just enough Alaskans that better laws and budgets would result from less deliberation, fewer hearings, and abbreviated time frames. The measure hadn't been fought aggressively by Juneau. We were happy enough that the Legislature was meeting here; no need to appear greedy and keep anyone longer than they wanted. Such is our eagerness to please the rest of the state.

As the shortened session approached we began to fully understand the implications of the change. With the Legislature here one-quarter less time there'd be a proportionate loss of economic benefit to our apartment renters, hotels, restaurants, grocery stores and part-time job seekers. In the Capitol, there'd be less time to deliberate, take public testimony, research, and find working compromises to complex bills and issues, increasing the likelihood that lawmakers would devote time to simple, easier, less important bills (the establishment of Marmot Day, for example). A shortened regular session would undoubtedly increase the need for more expensive special sessions, which might or might not be held in Juneau. All of this would increase the public's frustration with the Legislature as a body, and with Juneau as its home community. And the change would certainly strengthen the power of the executive branch, which could still take all year to formulate policy goals and master their details. So even though Governor Palin had nothing to do with the introduction of the 90-day legislative session, in Juneau we nonetheless associated our anxieties about the change with her administration.

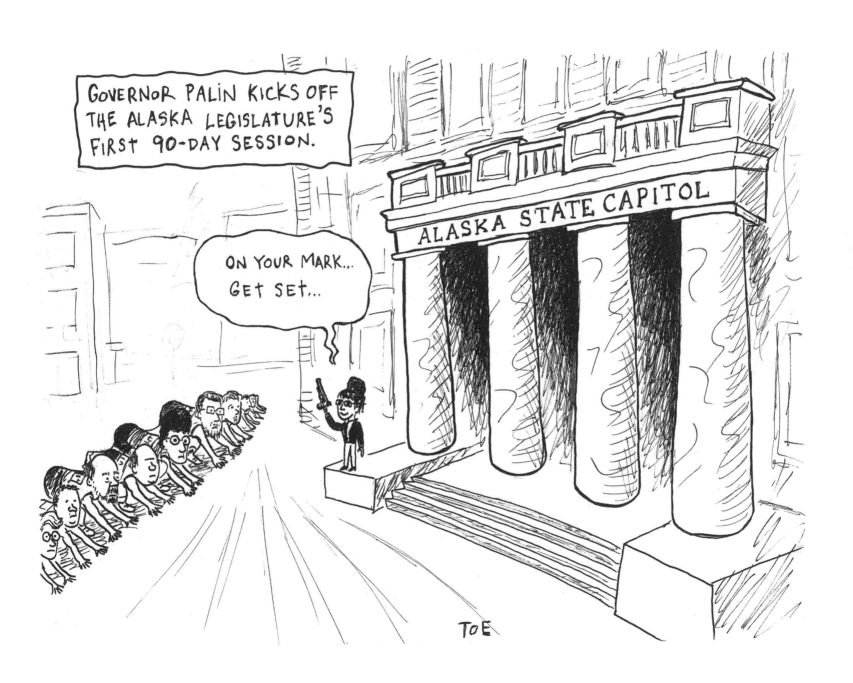

The Legislature's reconvening brought Governor Palin back with Senator Lyda Green, Senate President and fellow Mat-Su resident. The mutual disdain these two had for each other was familiar to anyone who spent time in the Capitol. Senator Green had voted against Governor Palin's oil tax reform bill and openly criticized aspects of her pipeline plan. When Palin had asked legislators where they wanted the previous fall's special session, Green had complained that Palin simply should make a decision and that she wasn't going to poll Senators—Sarah could do that herself. You had only to look at them to see that the two politicians were entirely different species. Palin, petite and cunning, looked like a Velociraptor next to Green's lumbering Tyrannosaurus.

As the Legislature settled in, the main order of business was determining how to move forward with the gas pipeline project that had been launched the previous year. In early January 2008 Governor Palin announced that she had a winner among the proposals she'd received from organizations interested in building the natural gas pipeline: the Calgary-based TransCanada Corporation, a medium-sized player in the oil and gas development game. A few other pipeline construction companies and oil producers—including ConocoPhillips—also had applied, but every proposal but TransCanada's failed to meet the requirements of Palin's proposal. ConocoPhillips executives argued that the AGIA pipeline simply couldn't work in its current form, and continued to beat that oil drum throughout the legislative session.

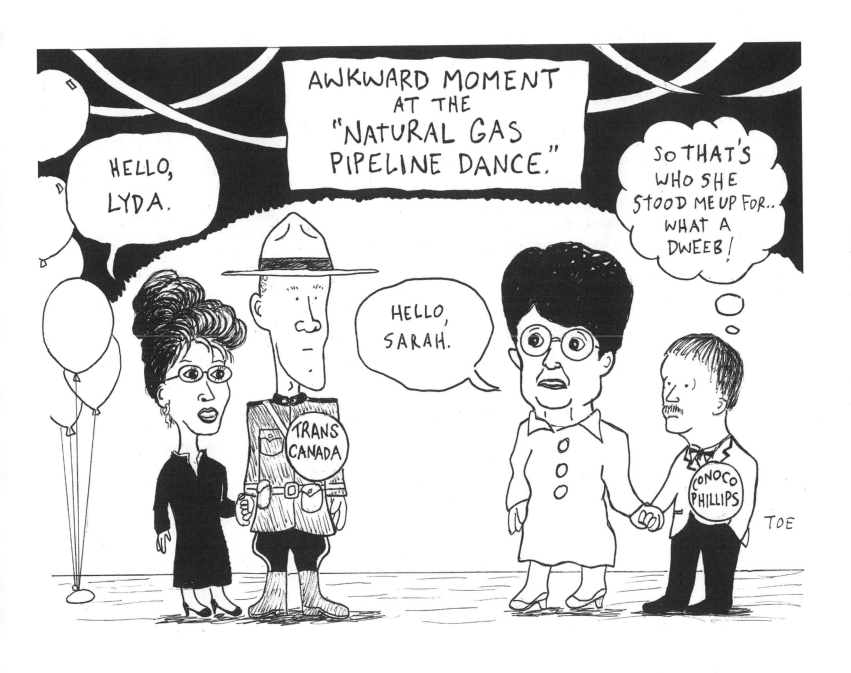

The governor remained focused on development of the pipeline through the first months of the legislative session, but did offer proposals in other areas—education, transportation, public safety. They were moderate proposals that continued to attract approval of both Democrats and moderate Republicans. It also dawned on legislators that Governor Palin's restructured oil tax, coupled with high oil prices, was resulting in a lot of extra money for the state. The two branches of government would have to work together to figure out what to do with it. But developments on all those things were eclipsed in early March, when Palin announced at a late-afternoon press conference that she was pregnant—that, in fact, she was due in just two months.

How had the press missed this? For that matter, why hadn't the Alaska media challenged Palin on much of anything throughout her governorship, or her campaign? Legislators and agency administrators had by now accepted that she was not really absorbed by the day-to-day details of governing. She was, however, clearly interested in the increasing attention being directed her way: a photo spread in *Vogue* magazine, and now the talk that she was a potential vice-presidential candidate. Everywhere she was being celebrated as a new kind of governor. But virtually no media outlets were dissecting her record and style with a critical eye. Why?

It's good to stop a moment and recognize what was happening in Alaska and the media world. Newspapers, the traditional home of the investigative journalists, were in the throes of their biggest and most painful restructure ever, thanks to the Internet. Those journalists that hadn't been laid off were expected to pick up the extra work, and so felt embattled on all sides. In Sarah Palin, perhaps, they saw a compatriot in their efforts to call corrupt legislators and powerful corporate interests on the carpet. Like the rest of us, they identified something in Sarah Palin that they wanted to see in themselves. It was a mutually supportive and symbiotic relationship, and there was, to this point, little reason to challenge it. Publishers and producers wanted readers and viewers, and readers and viewers liked Sarah Palin. The breaking news of her pregnancy was the most popular web story in the *Juneau Empire's* history.

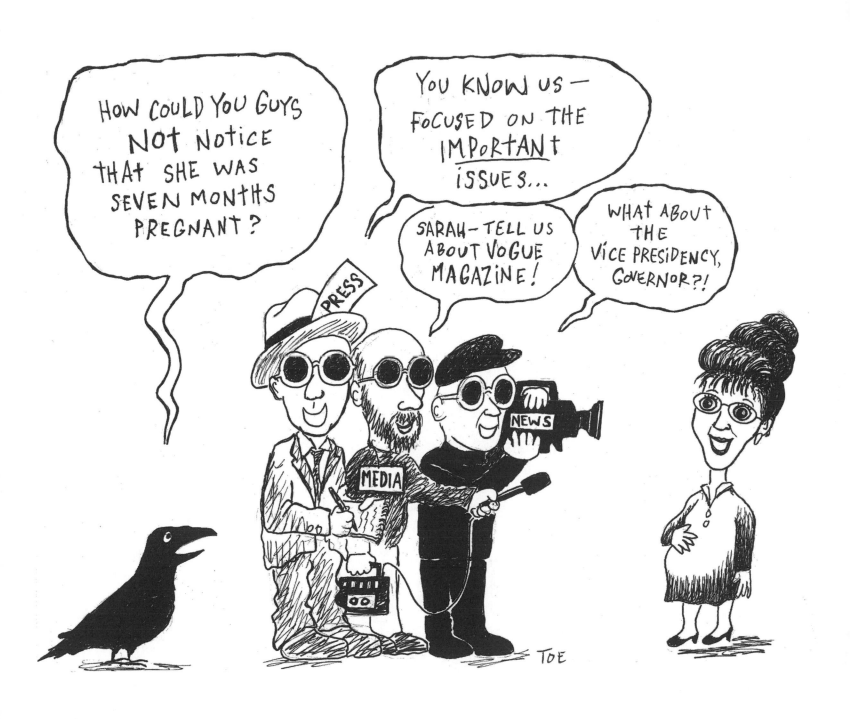

April, 2008

The legislative session wound down with Governor Palin still in the driver's seat. Legislators waited for her next move on the natural gas pipeline; for her to finish her review of TransCanada's application and public comments on it; for her to call a special session for the Legislature to take up the application.

They waited on her decisions on the capital projects they proposed for their districts. She asked lawmakers to come to her office in groups of three to justify each of the once-vetoed projects that had been added to the supplemental budget. In the end, and even though the state's bank account was fat with oil revenues, she vetoed $208 million in legislators' projects, leaving many even more disappointed and upset than they'd been the year before, when she'd also unceremoniously squashed their capital projects. Senator Bert Stedman, a Republican from Sitka, said the governor had failed to follow through on her promises of improved relationships with the Legislature. "Open and transparent, good communications, is all hogwash," he told the *Juneau Empire*.

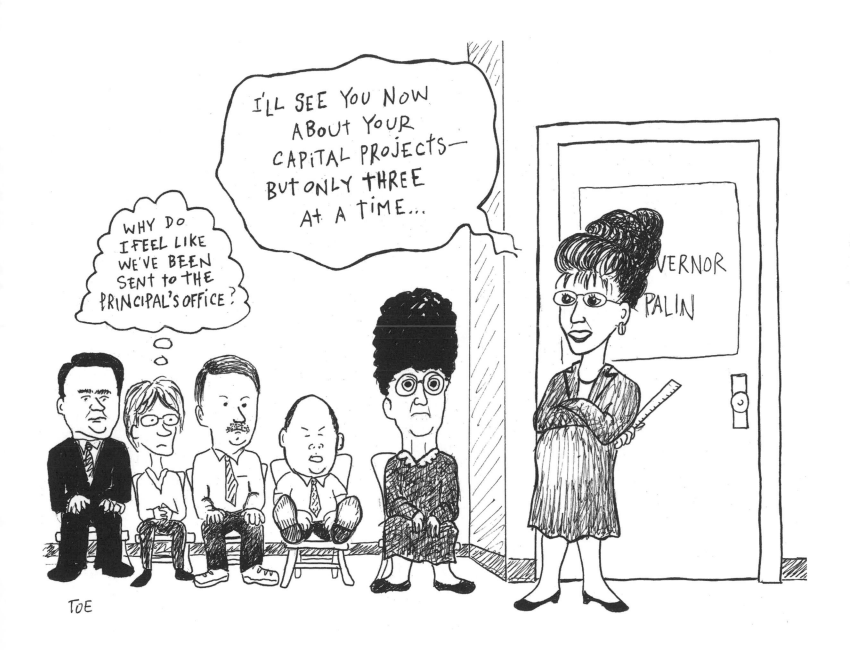

The mood outside the Capitol Building was just as foul as the one inside.

Juneau had already watched anxiously as a bill that would allow a new legislative hall to be built outside of Juneau made it through a couple of House committees. We thought Governor Palin was too quick to announce that if the Legislature moved, the top executive branch offices, including the governor's, would relocate along with them.

Then, an act of God: a late-season avalanche knocked out the lines and towers connecting the city to its primary power source, a hydroelectric plant several miles south of town. Knowing that our electrical bills would now quadruple or more because power would be coming from expensive diesel-run generators, we immediately started conserving: keeping the lights off, using our wood stoves to stay warm, and cooking with our ovens as little as possible. We appealed to the governor for disaster relief, which she rejected because this was not an urgent need to protect our health and safety. We instead turned to our own city rainy day fund to develop an assistance plan to help each other with the high costs.

While Juneau residents pondered how they would afford this jump in their living expenses, money continued to flow to the state thanks to high oil revenues and an updated tax structure. Governor Palin proposed using the windfall to subsidize energy costs for Alaskans. The government didn't need the money, so why should the government—why should *Juneau*—get it all? And so instead of using that money to develop a long-range economic plan; or incubate alternative energy resources; or develop a health care plan for Alaskans, she chose to give it directly to Alaskans. This check, combined with our annual permanent fund dividend check, resulted in every man, woman, and child in Alaska receiving $3,269 from the state government in 2008. It didn't do much to gain Juneau's affection, but the rest of the state found her all the easier to like.

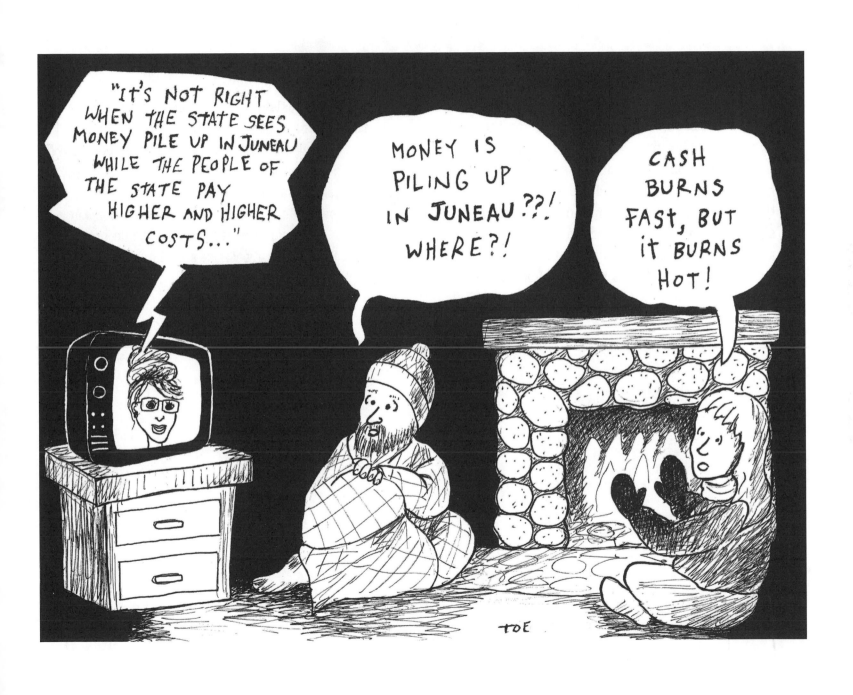

Governor Palin and legislative leaders agreed to take their hearings about the pipeline on the road, to gather public input before they would cast their crucial votes. Clear differences of opinion had emerged among legislators about whether the state had limited its options by backing a single company, and whether the pipeline should be an entirely in-state line that could benefit Alaskans better than if it cut east toward a hub in Canada. Debate and discussion was heated at times. While a number of legislators were clearly chafing under the restrictions of her AGIA plan, Palin's popularity seemed to prevent them from doing much about it. However, Governor Palin's strongest adversary in the Legislature had had enough. As the "road show" was about to get underway, Senator Lyda Green announced that she would not be running for reelection because she simply could not support the governor's plan.

SCENES FROM THE ALASKA LEGISLATURE'S
GASLINE ROADSHOW

Boarding the bus in Juneau.

Gov. Palin insisted on driving.

Rep. Kawasaki kept asking, "Are we there yet?"

Hitting the restroom in Cantwell.

The crowd in Kenai loved our "Gasline Finale."

Where ya going, Senator Green?

TOE

June, 2008

Maybe at this point things were so bad in Juneau that even Governor Palin felt sorry for us. The power outage, the subsequent dramatic rise in our utility rates, and the way we responded by immediately dropping our power usage by a third began attracting national attention. The governor noted Juneau's unusual situation in her press conferences and provided a $1.5 million loan to help the city recover from economic injury. She wrote a letter to the *Juneau Empire* commending our conservation efforts, and congratulating our power company

for getting the transmission lines prepared faster than we expected. Add to that her unwillingness to support a proposal to move the Alaska Permanent Fund Corporation offices out of town, and we started to wonder: was Governor Palin's frosty attitude toward Juneau starting to thaw? Would she, in her second year, finally put any reservations and mistrust for Juneau behind her, and come to enjoy working and living here as much as we did?

We'd never get a chance to find out.

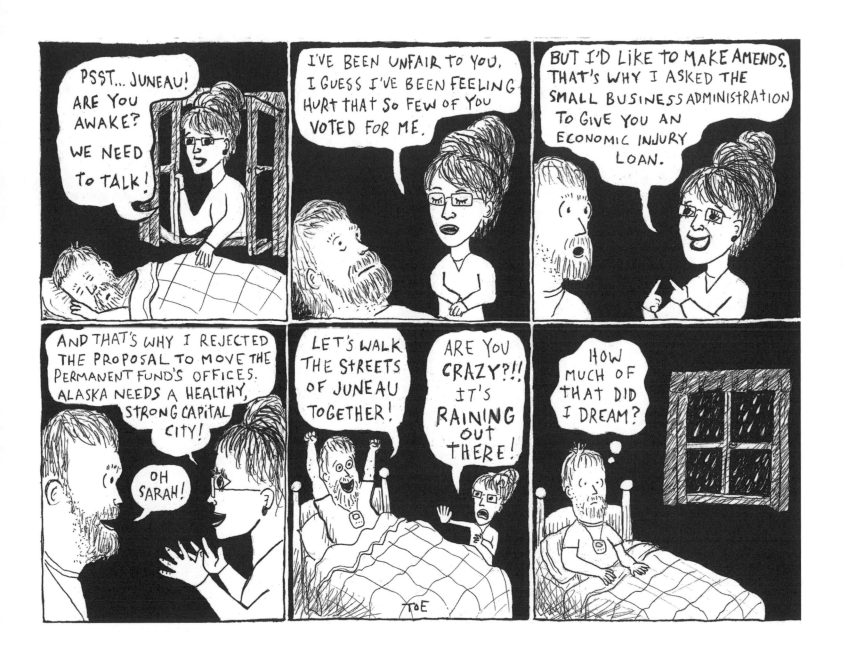

RUNNING MATE

August, 2008

Alaskans can remember exactly where we were when we heard John McCain named Sarah Palin as his running mate in the 2008 election. Most of us woke to the news; when momentous news strikes the country Alaskans are often among the last to know, as we sleep away in the quiet solitude of the Alaska time zone. We turned on our radios and TVs to hear newscasters sputtering and scrambling to share what little they knew about Ms. Palin, this new personality from Alaska (Alaska! So remote it doesn't even appear on a lot of maps of the United States!) who would suddenly matter very much. We woke our spouses to tell them the news, and they didn't believe us.

Yes, her approval ratings in most of Alaska were through the roof. Yes, she had exerted real resolve and courage toward our political and corporate establishments. Yes, she was a fresh-faced alternative to the usual Republican leadership. And yes, the possibility that she could be interviewed and maybe even selected as a vice-presidential candidate had been mentioned before, and we were aware of that. But don't let any Alaskan tell you otherwise: it was a bigger surprise to us than it was to the rest of the country.

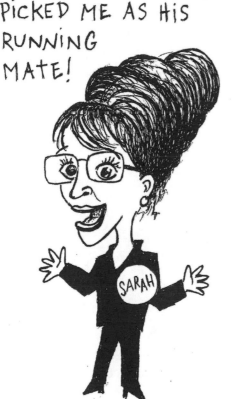

TOE

There would only be a week between McCain's announcement and Palin's appearance at the Republican National Convention. During that week she made few appearances and gave few interviews. It was just enough time for Americans to be overcome with anticipation, heightened by the dearth of information anyone outside Alaska had about this individual on whom McCain had staked his candidacy. But even though Alaskans knew more about her, the anticipation was even thicker here. Wasn't it just a few weeks ago that she was working out in our local fitness center, waiting in line with us at the drive-thru espresso stand? As we gathered around our TVs, we thought of her, waiting backstage, and we wondered if any of us had the iron to do what she was about to do. She stepped on to the massive stage, the crowd roared like a hurricane, and these were our thoughts:

1. She's looking calm, she's looking poised.
2. Look at those kids, that husband, the baby! Cute!
3. Praise the boss first. Smart move.
4. She's doing it! She's on her game, she's nailing this speech!
5. Great lines about small towns and Harry Truman. Bet she never said "haberdasher" before.
6. Has she always spoken with that accent? Where's that from, anyway? Michigan?
7. "Families of special needs children will have a friend and advocate in the White House?" Really? Had we missed something she'd done for those families in Alaska?
8. "I guess a small town mayor is sort of like a community organizer, except you have actual responsibilities." Funny.
9. "The difference between a hockey mom and a pit bull? Lipstick." Funny, but we'd heard it before.
10. "I put it on eBay!" They loved it as much as we did!
11. "Thanks but no thanks to that bridge to nowhere. . . ." Huh?
12. Who knew she was so *mad*?

In days to come we'd pick apart the particulars of the speech, which we all knew was written by someone else. And plenty of critics would point out that all she'd done, really, was read words off a teleprompter. But she didn't just read them, she sold them under indescribable pressure. You had to hand it to her: She'd risen to the occasion.

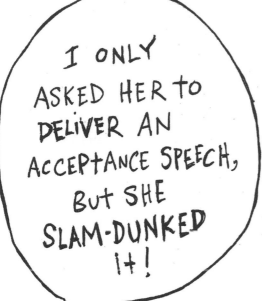
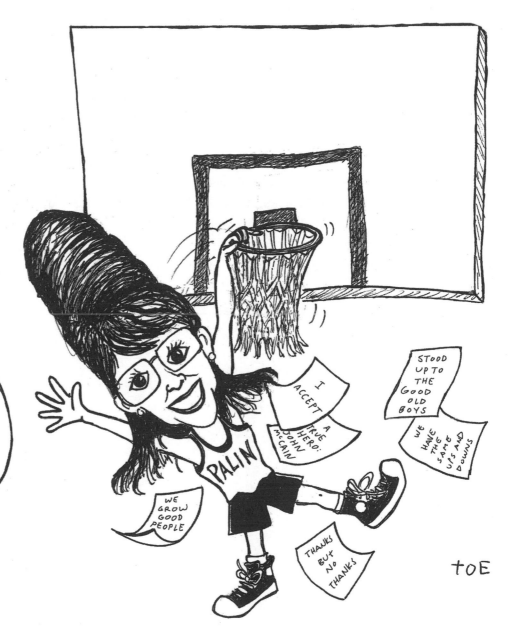

And as she was thrust into the national spotlight, so was Alaska. So were *Alaskans*. Many of us were still on our summer vacations, or entertaining summer visitors, when interest in Sarah Palin exploded like a supernova. When we stopped at the car rental booth in Seattle or Washington DC the agent asked us about her; when we pulled out our Alaska Airlines credit cards in restaurants or shops in New York or Montana the waitress or cashier asked for our opinion. Some of us jotted down our thoughts about our governor and emailed them to our friends; these friends, in turn, forwarded our emails across the country and overseas. The Governor's House in Juneau, up to now a second-tier attraction that most cruise-ship passengers would just as soon skip, was now a must-see destination, attracting crowds hoping to catch a glimpse of the governor, to make some connection to the places she'd walked. No longer was Alaska the most remote corner of the world; we were now the center of the political universe.

ALASKANS, YOU KNOW YOU LOVE IT

Panel 1:

YOU LOVE GETTING PHONE CALLS AND EMAILS FROM LONG-LOST FRIENDS.

> PAUL?! WHAT'S IT BEEN — TWENTY YEARS?!

> WHATEVER — TELL ME ABOUT SARAH PALIN!

Panel 2:

YOU LOVE IT THAT YOUR RELATIVES DOWN SOUTH ARE FINALLY INTERESTED IN YOUR OPINION.

> LET ME TELL YOU HOW ALL THIS LOOKS FROM MY PERSPECTIVE..

Panel 3:

YOU LOVE THAT YOU CAN TELL STORIES ABOUT YOUR RELATIONSHIP WITH A MAJOR CELEBRITY WITHOUT STRETCHING THE TRUTH. (MUCH.)

> I DON'T KNOW HER WELL... BUT SHE DID HAVE ME OVER DURING THE HOLIDAYS...

> REALLY?!

> THE OPEN HOUSE?

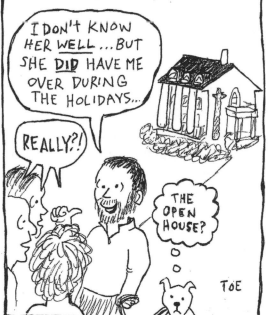

TOE

But back at home trouble was brewing for Sarah Palin. The campaign was inviting scrutiny from outside media, and reporters began arriving in Juneau, Anchorage, and Wasilla to examine her records and actions as mayor and governor.

One action, in particular, caught their attention. Back in July, shortly before McCain plucked her as his running mate, Governor Palin had fired her public safety commissioner, Walt Monegan, saying only that she wanted new leadership that would set a new direction for the Department—nothing more specific than that. There were no public signs warning us that Monegan—a longtime police supervisor in Anchorage—was having any trouble. But a few days later Monegan speculated in the media that he had actually been fired because the Palins were unhappy that he hadn't fired a state trooper, Mike Wooten, who was the ex-husband of the governor's sister.

Monegan said he'd received pressure from the governor, Todd Palin and governor's staffers to fire Wooten; all of them quickly issued denials or kept their mouths shut. But both the national media and Alaska's wouldn't let the story go, and uncovered a host of details about Palin's extended family and its history of divorce, threats, restraining orders, vendettas, and score settling. The public records regarding the sister's divorce, Wooten's disciplinary issues and the Palin family's involvement reads like a transcript from *Judge Judy* hearing *Hatfields v McCoys*.

As the summer progressed Alaskans weren't sure what had happened, nor could we be sure how much of the reaction to the matter was politically motivated. The stew of rumors, speculation, accusations, denials, inabilities-to-recall, and mis-remembered information, issued by the usual cast members (press secretaries, attorneys, legislators) of every political scandal, was given a name: Troopergate. It became a significant distraction from the campaign and roused Alaskans to take a harder look at their governor.

Troopergate shined a light on Todd Palin. This tall, athletic, silent but evidently cheerful man had remained pretty much an unknown quantity for Alaskans throughout his wife's political career, and even her elevation to governor hadn't changed that. That was okay—if he was going to stay at home and do the child-rearing while she governed, and all he needed was to run an occasional snow-machine race or some weeks away to fish, that was fine and even admirable to us.

But the investigations into Troopergate revealed that's not what he'd been doing. He was going to the governor's office, using her computer, sending emails, sitting in on meetings, contacting aides and commissioners directly, and frequently advising his wife about...about what? Aside from a brief flirtation with the Alaska Independence Party, nothing indicated that he had an interest in a particular public policy or issue, or that he held particularly strong views on anything. His predecessor as first spouse, Nancy Murkowski, had used her position to advocate for breast cancer prevention and treatment; before that, Governor Tony Knowles's wife Susan had participated in anti-smoking campaigns and arts forums. Somewhere along his wife's quest for governor someone had interviewed Todd Palin about his interests, and he'd mentioned a "passion" for workforce development and vocational training. Where was the evidence of this passion? Had he ever seized on the issue by convening a public forum, filming a public service message, or simply visiting a vocational school to lend some high-profile support?

We didn't expect him to host teas or receptions in the Governor's House if he didn't want to; it would be out of character for him anyway. But we also didn't expect him to be omnipresent in the governor's office, busily occupying himself and influencing government in a shadowy zone that was somehow both outside and inside the bounds of law and appropriateness. The light that shined on Todd Palin thanks to Troopergate only revealed more shadows.

Troopergate was now a major distraction from the presidential campaign, but something else was becoming an even bigger distraction: Sarah Palin herself.

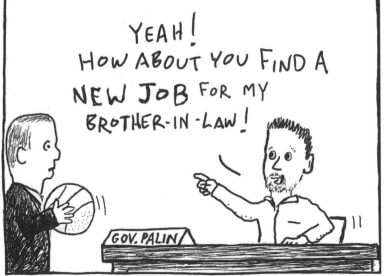

Shortly after the convention speech Sarah Palin sat for a couple of interviews with network news celebrities—Charlie Gibson of ABC, Katie Couric of CBS. Both appearances were disastrous. Palin obviously had her head jam-packed with factoids and talking points, as if she could memorize her way through conversations about domestic and foreign issues, and wound up providing unintelligible, meandering answers and groping for catchphrases. When she stepped away from these platitudes to answer simple questions on which she should have been able to provide direct answers—why living in Alaska gives her necessary foreign policy experience, or what newspapers or magazines she reads—she was at a loss.

She looked miserable, too, tense in her chair as she faced off with Charlie Gibson, staring at the ground as she walked and chatted with Katie Couric, as if on a bad date she just wanted to end politely. In Alaska, we realized that we had never known her to sit for an interview this way, or seen her let a reporter weave a conversation with her that moved easily between her personal and professional lives. The interviews not only revealed how little Sarah Palin knew, they also revealed how little we knew about her. We were quick to remind our questioning friends that we had elected her governor not because she knew a lot, but because she knew *enough*; and because she knew the difference between right and wrong, between smart and stupid. Now we began to doubt her and ourselves. If Sarah Palin truly was as intellectually vacant as she appeared to be, what did that say about people who'd made her their governor?

In the middle of the campaign the United States took a sudden lurch toward economic disaster, and members of Congress met with President Bush to veer the country away from a financial cliff. If Palin was unable to opine sensibly about foreign policy, she was just as unprepared to talk coherently about sub-prime loan losses, bank and investment firm failures, and falling stock and housing prices. How could it be otherwise? She'd been governor for a year-and-a-half for a state with fat savings accounts and abundant assets. Nothing in her training or experience could have prepared her for this, and she certainly never expressed a personal interest in the details of economic policy. Nevertheless, she forged ahead, providing this answer when Katie Couric asked her why Americans should support Congress's and the President's new bailout package:

> That's why I say, I like every American I'm speaking with, were ill about this position that we have been put in where it is the tax payers looking to bailout.

But ultimately, what the bailout does is help those who are concerned about the health care reform that is needed to help shore up the economy.... Helping the — oh, it's got to be about job creation, too. Shoring up our economy and putting it back on the right track. So health care reform and reducing taxes and reining in spending has got to accompany tax reductions and tax relief for Americans. And trade—we've got to see trade as opportunity, not as a competitive scary thing. But one in five jobs being created in the trade sector today. We've got to look at that as more opportunity. All those things under the umbrella of job creation.

So nonsensical were her answers that the satirists on *Saturday Night Live* earned big laughs without altering a word in their skit re-enacting the interview.

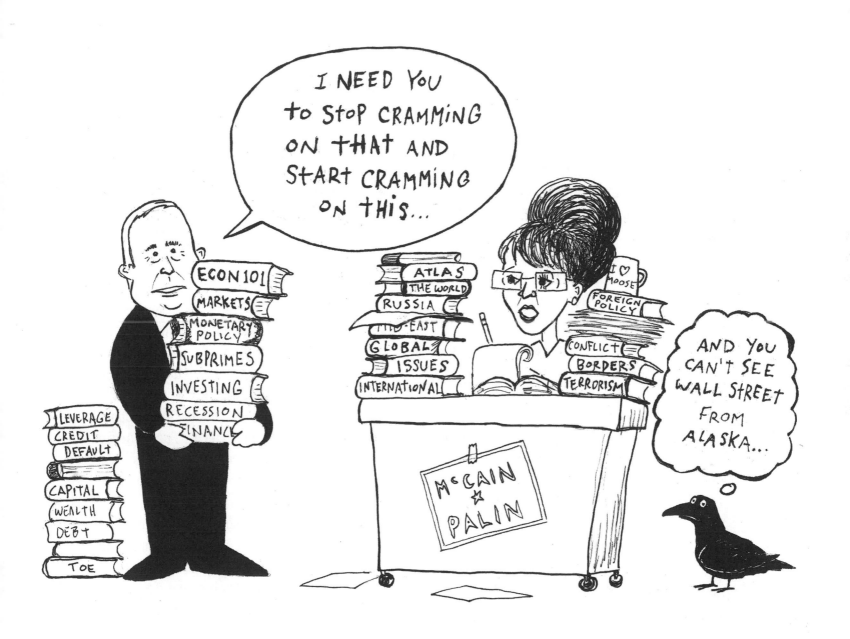

Her next major appearance would be her debate with the Democratic vice presidential nominee, Joe Biden. While the anticipation for the convention speech came from knowing so little about Palin, the anticipation now lay in wondering how bad she'd mess up in the debate. She wouldn't be able to get by reading a teleprompter. This time she'd have to parry, argue, and demonstrate a grasp of issues alongside a longtime, famously garrulous senator. If she was as woefully unprepared for national office as her TV appearances had led our Outside friends to believe, it would be impossible to hide.

John McCain added fuel to the anticipation by announcing, a few days before the debate, that the economy was in such urgent need of attention that the debate ought to be cancelled. Someone had apparently thought this might make him seem more presidential; instead it simply led credence to speculation that the real disaster he was trying to avert was his running mate's likely debate performance.

But the debate went forward, and it wasn't a disaster. Palin stepped up to the podium and stayed afloat on winks, smiles, and a passable amount of information. Nobody believed that she'd thought hard or penetratingly about any of the things they discussed, or even demonstrated that she found the subjects—world affairs, the economy, health care reform—particularly interesting. Instead the debate showed she could learn and be coached enough to keep from falling on her face. In the weird calculus of a political campaign, this was recognized as a kind of success.

But in Alaska we could see that Sarah Palin had made a choice. She could have acknowledged her shortcomings right away—the country would recognize them sooner or later—but then pointed to her record to show she could master the big picture, the right thing to do. We remembered how, in her campaign for governor, she knew when to cheerfully admit she didn't know the details, but to remind us that we could count on her character. We thought of how, as governor, she knew when to turn the press conference over to her experts so they could defend her position on oil taxes or ethics reform. What she hadn't done back then was try and fill her head with far too many facts and talking points and party lines to try and create an impression of knowledge and experience out of vapor. That's what she was doing now. To many of us, it was here, and not Election Day, when she lost.

A low point: Sarah Palin's appearance on *Saturday Night Live*. Perhaps she'd received advice from her managers that the appearance was just the thing needed to lighten the campaign and show a playful side; or maybe she'd made that determination herself. In either case demonstrating that she could be silly was not what Sarah Palin or the country needed at this point. She'd already established that she was silly, and not in an endearing way. What she needed was to take some time to sit for an intelligent and for god's sakes relaxed conversation about herself, her views, and how the McCain administration would pursue policies different from both the Bush administration and an Obama administration. The appearance pointed out the lie that the campaign simply kept her too busy to be able to hold such conversations, as she apparently had time to appear on a comedy show, in a skit that poked fun at Alaska Natives, Alaskans, her husband, and—though it was never clear she understood this—herself.

It left many Alaskans feeling cold.

There was more trouble at home. The *Washington Post* noticed what Alaskans knew well: that Governor Palin had not spent a great deal of time at the governor's residence in Juneau. The *new* news the *Post* uncovered was that she was accepting a "per diem" allowance—the extra pay government workers receive for costs they incur for having to buy meals and other incidental costs when they travel—for the time she lived at home, in Wasilla. The time amounted to 300 days, the total paid $16,000. The *Post* also found that she had charged the state for travel by her husband and children to various destinations in and out of state, including travel between Wasilla and Juneau—travel that wouldn't have needed to happen if they'd all simply lived in Juneau in the house provided for them.

We weren't much concerned about the amount of money. What was more worrisome was that, to accept it, she'd had to have knowingly rationalized her way through repeated expense reports and bank deposits, check after check. The Palin spokespeople repeatedly pointed out that her predecessor had run up far more in travel costs. But Frank Murkowski hadn't touted himself as both a fiscal conservative and a squeaky clean reformer. Murkowski hadn't stood in front of the world and said, "I got rid of a few things in the governor's office that I didn't believe our citizens should have to pay for."

It had been hard enough to bear her questions about Juneau's fitness as the State Capital and home to the Alaska Legislature. It had hurt enough when she decided to live most of her time out of Juneau. Now on top of that insult and injury she was rubbing salt: charging the state as if she viewed Juneau as her home-away-from-home all the time. True, she'd never broken a law or violated a rule. But the trust that a great many Alaskans had with her had been violated; whatever remaining bonds she had left with Juneauites were now broken.

And there was still Troopergate to contend with. In October, as the national campaign was reaching its climax, the bipartisan Alaska Legislative Council released a report by special investigator Stephen Branchflower finding that Palin had violated the ethics law covering state executive employees. The statement Palin issued in response made us wonder if she had misheard the news, or if she was pushing, on advice of campaign staff, political spin to its furthest limits. She said: "I'm very pleased to be cleared of any legal wrongdoing, any hint of any kind of unethical activity there."

Though she was a disaster as a vice-presidential candidate, and the goodwill she'd enjoyed in Alaska was crumbling, something much different was happening on the ground of her campaign stops and rallies. There were wide swaths of the population for whom Sarah Palin was a godsend, a breath of fresh air, the answer. She was lighting crowds on fire, and seemed more of a draw than the presidential candidate himself.

Surely this was, in part, because so much of the country still knew so little about her, and because much of the country knew so little about Alaska. They placed in her their fantasies about a people and a place that were untamed and free. They placed in her their hope that people of courage really existed and could succeed; that a person of faith could be beautiful and smart. Why shouldn't they? Alaskans had placed their fantasies about what it meant to be an Alaskan in Sarah Palin. Now crowds of people with very specific ideas about what it meant to be an American were projecting those thoughts onto her as well. We could hardly blame them.

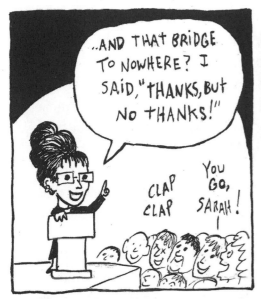

Overall, though, the news for McCain-Palin was bad. Some media outlets, upon learning that the Republican National Committee had spent around $150,000 on high-end clothes for Palin and her family, said this was proof that the small-town hockey mom image was in fact a concoction. (The wardrobe spending didn't seem such a cardinal sin to many Alaskans. When we finally get out of state for a visit to the big city the first thing many of us do is hit department stores and overspend.)

Tensions between McCain and Palin became public when a couple of anonymous McCain aides "leaked" their concerns about Palin to the news media. They complained that she was difficult to handle, wasn't taking direction, and kept insisting that she knew best what the campaign needed. The aides faulted her for publicly disagreeing with the decision to close campaign headquarters in swing-state Michigan to cut their losses there. And they acknowledged that, yes, she was now confined to carefully selected public appearances and talking points full of bromides, such as saying candidate Obama's policy toward Iraq was basically a "white flag of surrender," but giving her no opportunity to discuss his position, or McCain's, in any substantive way. The anonymous concerns were clearly an effort by McCain staffers to distance themselves from the running mate. But it backfired, making Palin appear more sympathetic. The team wasn't covering her back; they were scrambling for cover, and it was every man and woman for themselves.

November, 2008

In the final days of the campaign Palin was running around the country at breakneck speed, openly calling Obama a socialist and doing her best to explain why the change he represented wasn't the change the country needed. Alaskans, in true red-state fashion, would stick with the Republicans on Election Day. We nevertheless got all the change the country voted for, and then some.

WHILE SHE'S OUT THERE CAMPAIGNING, BACK HERE I FEEL LIKE WE ALASKANS HAVE BEEN HAD.

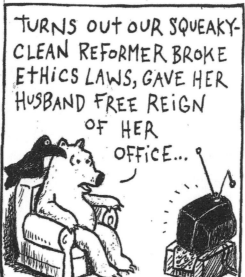

TURNS OUT OUR SQUEAKY-CLEAN REFORMER BROKE ETHICS LAWS, GAVE HER HUSBAND FREE REIGN OF HER OFFICE...

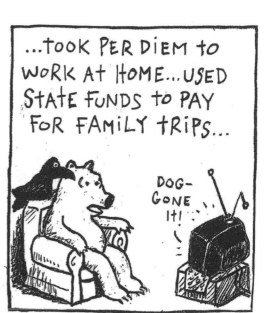

...TOOK PER DIEM to WORK AT HOME...USED STATE FUNDS TO PAY FOR FAMILY TRIPS...

DOG-GONE IT!

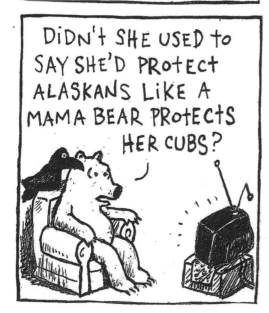

DIDN'T SHE USED TO SAY SHE'D PROTECT ALASKANS LIKE A MAMA BEAR PROTECTS HER CUBS?

YOU BETCHA!

TOE

DON'T BEARS SOMETIMES EAT THEIR OFFSPRING?

ONLY WHEN IT'S IN THEIR BEST INTEREST.

November, 2008

A dull but devoted spouse waits for his bride to return home after she's taken a long, exciting, life-changing trip without him. He waits feeling a mixture of anticipation and dread. Maybe she'll be relieved to be home. Maybe it will be awkward for them to talk about some of the experiences she had without him, and some of the revelations he's had about their marriage in her absence.

Maybe she'll quickly grow restless and bored with domesticity, now that she's had a taste of the wider world's promise and possibilities. Palin returned to Alaska at almost the darkest time of year, when the sun comes up in her hometown in late morning and is gone by early afternoon, and in the weeks to come it will only get darker.

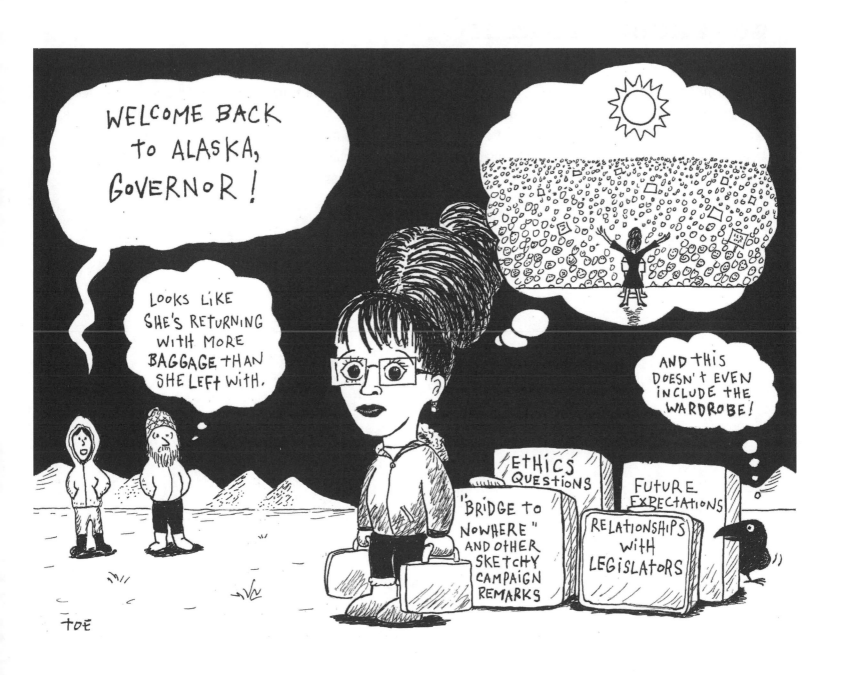

GOVERNOR - PART II

November, 2008

Maybe Palin believed herself when she said she was glad the "drama" had come to an end, and that she wanted to get back to her work of being a governor, wife, and mother. But the media weren't going to let her go; the work of vetting this near-vice-president wasn't done. And particular conservative crowds were still interested in making direct connections with her. Word was that she could now fetch upwards of $100,000 for a single speech—more than even former presidents could command.

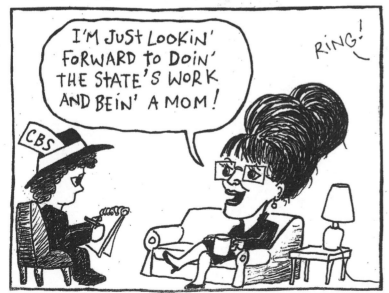
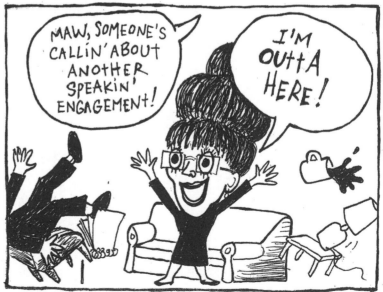

November, 2008

The wide-ranging investigation into the relationship between VECO and Alaskan political figures that had begun back in 2007, when Sarah was still a candidate for governor, had continued throughout the presidential campaign and was now winding down. The investigation had, by now, hooked its biggest fish, the quarry we suspected it had been trawling for all along: Senator Ted Stevens, our 86-year-old Alaskan of the Century, found guilty for making false statements regarding his relationship with old VECO. Sarah Palin, like most Republicans, would ask him to step down. It was a moot request; a few days after his conviction, on the same Election Day that Sarah Palin would lose her vice-presidential bid, Uncle Ted lost his Senate seat of 41 years. None of us wanted to see him go to jail, and we didn't fault his attorneys for continuing to fight the conviction (which was eventually determined to be tainted and thrown out).

Palin, meanwhile, slowly returned to the mundane functions of being governor. She grimly read the traditional pardon for a Wasilla turkey and then stopped for an interview while a farm worker slaughtered turkeys behind her.

December, 2008

The election was behind us and our governor was back at home. Alaska was pretty quiet for the holidays. The high oil prices that had contributed to the budget surpluses in past years were low again; Palin introduced a budget for the coming year that made a few cuts. The Troopergate scandal ended with a whimper, with the Alaska Personnel Board finding Sarah not guilty of anything, contradicting the findings of the Legislature's Branchflower report. Neither report requested or required any sanctions or reprimands.

At least one newspaper called on Palin to release the transcript of her deposition—which she'd said she wanted to do during the campaign—but she now refused, leaving discrepancies between her side of the story and others unaddressed. The per diem scandal had pretty much run its course as well; after all, she hadn't broken the law; in fact, her staff said, she would continue to claim the per diem as long as she was working out of her home. Somehow, went their argument, this was saving the state money.

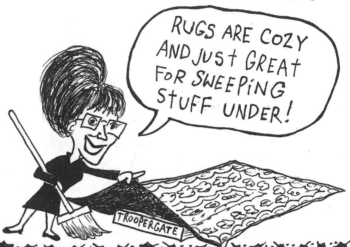

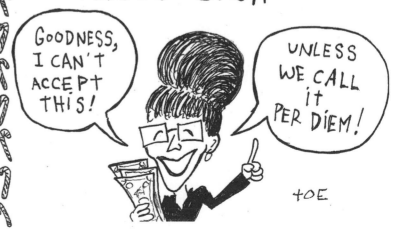

January, 2009

In Juneau we were assessing the impacts of her two years as governor. The *Anchorage Daily News* uncovered a 2007 email from Palin to her staff that read: "Come end of legislative session I'm joining YOU, and the majority of the people of AK, by conducting the state's business where the people are – where I can access them, and they can access me. . . . We're going to have to fundamentally change some perceptions of WHERE the admin needs to conduct its business in order to stay connected w/the world outside of Juneau." At virtually the same time that the staff were reading this email, we remembered, her spokespeople were maintaining that the renovations to the Governor's House were the reason she could not stay in Juneau.

But Palin wasn't expecting anything of herself that she wasn't expecting of her staff. By now, 11 of her 14 commissioners were living outside of Juneau, most in Anchorage. Between 2007 and 2008, 145 state government jobs had left the capital city and had been transferred to other parts of the state.

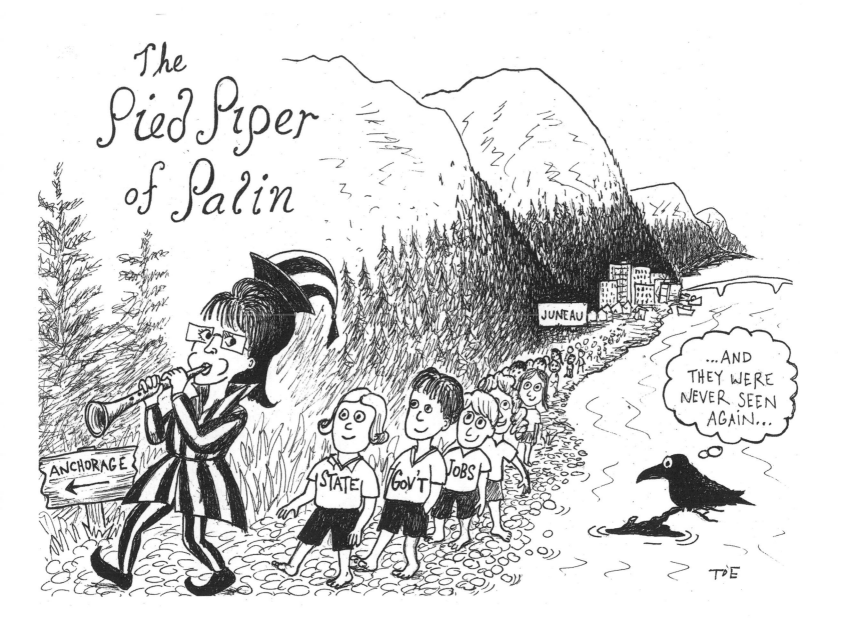

The Legislature and Governor Palin returned to Juneau for the regular session. Her relationships with the Democratic and Republican legislators she'd gotten along with in the previous session had taken a beating during the presidential campaign, thanks especially to the legislative investigation of Troopergate and its release; and there were still quite a few legislators who'd never gotten along with her in the first place. Oil prices had also dropped, meaning that Alaskans wouldn't be packing away the savings they had grown accustomed to and setting the stage for battles with legislators over the operating and capital budgets.

Palin kicked off the session well enough, proposing a budget that legislators generally agreed was "prudent." She also introduced a bill to establish a commission to improve health care coverage in the state, and a proposal to increase the state's use of renewable energy sources. But those residents of Juneau who worked in the Capitol noticed a change of mood. It became virtually impossible to learn about the governor's positions on anything. Palin wasn't just avoiding taking stances on bills; she wasn't even letting her own staff know what, if anything, they could say about them. Her office had already chewed through three legislative directors and now was looking to hire a fourth. She drastically reduced her press conferences, and many noted that she seemed tense and far less accessible than in her two previous sessions. The supplemental budget Palin sent the Legislature called for spending $269 million less than had been planned, but most of the decrease was due to a $200 million reduction in tax credits for the oil industry, which would likely be paid in a future year. Another $15 million in reductions came from the Medicaid spending authority that legislators said was not going to be spent anyway. Palin promised actual reductions in departments throughout state government, but mostly listed those amounts as "unallocated reductions" that she expected individual department heads to find later. Legislators found it confusing, too.

Frustration lingered that Todd Palin and several staffers had never submitted to subpoenas for interviews with the investigator in the Troopergate matter. The State Senate passed a resolution finding them in contempt.

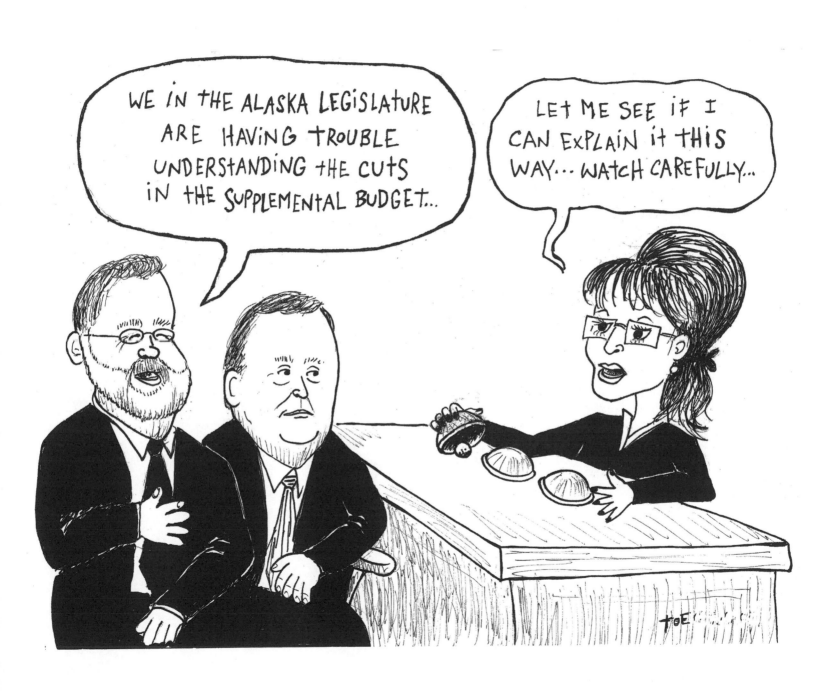

February, 2009

As the session continued the Legislature, and the rest of Alaskans, were increasingly concerned about Palin's focus. That concern spilled openly into view when Palin revealed that she was setting up a political action committee, SarahPAC. While this might not outright confirm her intention to run for President in 2012, it did indicate that she intended to remain a regular on the national political stage.

The website said SarahPAC would enable her to be a strong voice for energy independence and reform, and to provide support for local and national candidates who share Governor Palin's ideas and goals for the nation. Back at home, we wondered if our governor any longer had ideas and goals for Alaska.

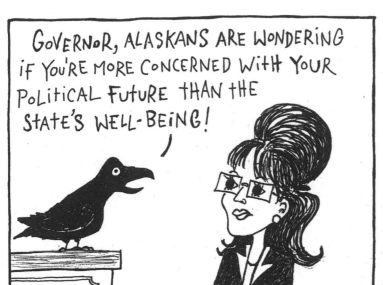

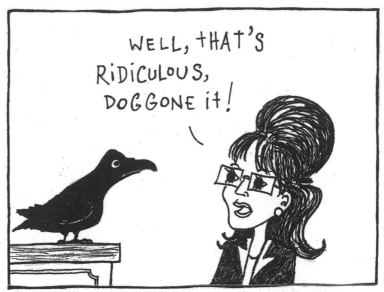

March, 2009

In early January, Mt. Redoubt, a temperamental volcano across Cook Inlet from Anchorage, started spewing plumes of gas and ash. Local earthquakes around the volcano increased, and vulcanologists predicted that eruption was imminent. It was nice to imagine that our governor was monitoring the situation closely and would assure us that safety plans were in place, but in fact she wasn't holding press conferences much anymore, instead issuing statements and letting her public information team meet with the press.

In one of these meetings, her press secretary brought up the per diem issue that had distracted us during the presidential campaign and apparently continued to rankle his boss. He reiterated that Palin's travel and per diem had cost the state far less than Murkowski's expenses, and complained that the press had treated Palin unfairly. He announced that the governor would be voluntarily giving money back to the state on a whole host of trips her family had taken—trips like Bristol's to see a performance of *Beauty and the Beast*, or airfare for Piper to attend the opening of the Iron Dog snow machine race. Her staff again emphasized that the governor had never broken the law, and again spoke of the unfair treatment she'd received—clearly messages the boss had wanted conveyed.

The governor was simmering just like Mt. Redoubt and might blow any moment.

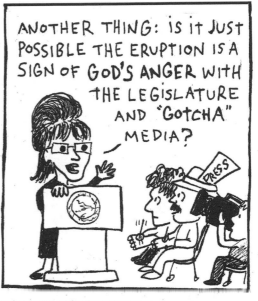

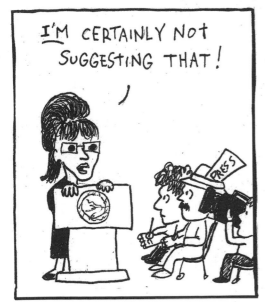

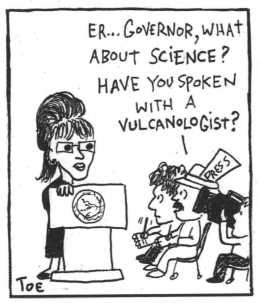

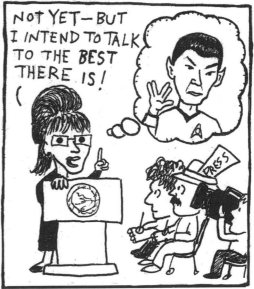

Now comes the incident that laid bare the full extent of Sarah Palin's disregard for Juneau, and the degree to which partisanship and spitefulness were characterizing her remaining time in office.

Soon after Barak Obama was inaugurated president rumors began circulating that Juneau's very own state senator, Kim Elton, was under consideration for a position in the new administration. By early March the rumors were confirmed, and he left Juneau for Washington DC and the job of director of Alaskan affairs for the interior department. Juneau was sorry to see him go; he was a longtime local public official, former newspaper editor, and familiar figure around town. Palin wasn't so sorry about his departure, though. She noted that Elton had been a prominent supporter of President Obama in his campaign. She didn't note that Elton also had chaired the legislative committee investigating Troopergate.

Elton's transfer created a vacancy in Juneau's lone state senate seat. The Constitution requires that the governor fill such a seat within 30 days; her candidate would then be subject to the approval of the Senate Democrats. The local Democratic Party solicited interest from locals but we all knew who they wanted: Rep. Beth Kerttula, Juneau's only Democrat House member and leader of the House minority. Kerttula's was the only name the Party forwarded to Palin. The governor was silent for almost a month before Palin's staff said she was not going to select Kerttula (who had, after all, made the fatal mistake of questioning Palin's readiness to serve as vice president). Palin's staff said she wanted other interested Alaskans to apply directly to her office. Palin herself was pretty much silent; we were left to assume she was either doing this as payback for Troopergate and Juneau's rejection of McCain-Palin (and maybe even Palin-Parnell), or that this was one more detail of governing for which she had no interest.

Just two days before her deadline Palin recommended Tim Grussendorf for the Juneau Senate seat. Grussendorf, a legislative staffer, had been a registered Republican until a few weeks earlier. He had switched his party affiliation to Democrat when Elton's seat became available. The Senate Democrats rejected him. A standoff-within-a-standoff ensued, in which Palin charged that Democrats had acted unlawfully because they'd made the decision behind closed doors (forgetting, it seems, that just about everything at the Capitol occurs behind closed doors). Palin then selected an administrator at the University of Alaska campus in Juneau, Joe Nelson, but the Democrats in the Senate rejected him as well.

While all this was going on, another showdown between Palin and the Legislature was emerging. Governor Palin's attorney general through her first two years, a tall, quiet man named Talis Colberg, had resigned from his position. Rumor was he didn't have a heart for the political shenanigans that had taken hold in the second year of Palin's governorship. Palin nominated Wayne Anthony Ross as her new attorney general. A stout, opinionated lawyer who proudly brandished his initials, W.A.R., on his license plates, Ross had, largely through opinion pieces he'd written in the 1980s and 1990s, offended Alaska Natives, environmentalists, women's rights groups, and others. His nomination for attorney general was in trouble before he'd even appeared in front of a committee hearing.

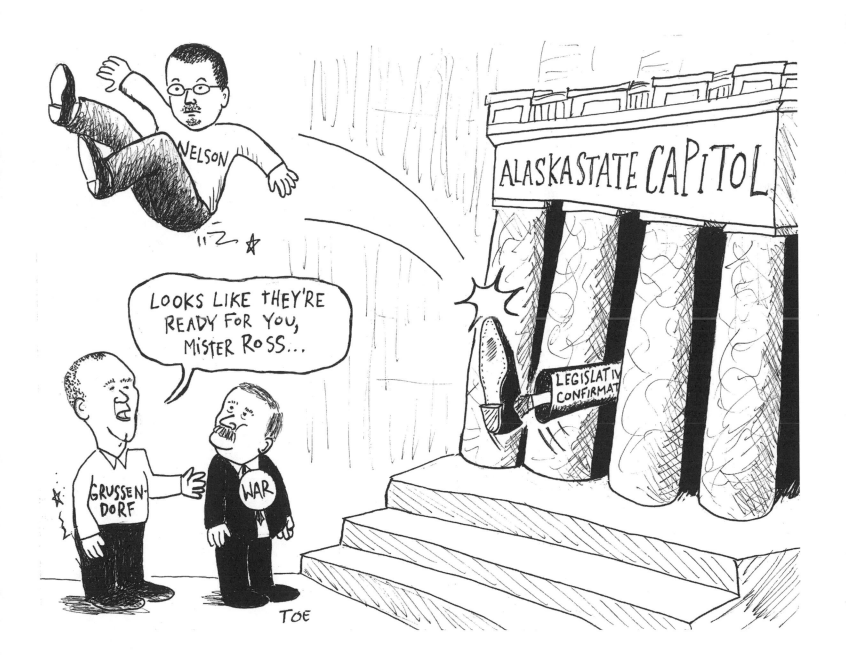

Juneau had by now spent a significant portion of the Legislative session without any representation in the State Senate. As the session entered its last few days the standoff between Democrats and Palin remained. Palin submitted a new name—Alan Wilson—and then submitted Tim Grussendorf's name a second time. Then she called for Senate Republicans to be able to participate in the approval of a designee; and then she called for the public to fill the seat by special election. The Senate didn't respond.

Who had advised Palin to take this strident, scattershot approach to the open Senate seat? That turned out to be her nominee for attorney general, which Ross openly acknowledged. If Palin's relationship with the Legislature had been a pile-up thanks to Troopergate, her budget vetoes, and now Juneau's Senate seat, this crash was now about to burn.

OKAY, JUNEAU... HERE'S EVEN MORE NOMINEES FOR THE STATE SENATE SEAT...

MY MOM'S HAIRDRESSER CHERYL

- LIFE-LONG DEMOCRAT
- SEEMS TO KNOW EVERYONE
- SHE'S A HOOT

MY NEIGHBOR'S CAT SKITTLES

- POLITICALLY CUNNING
- EXPERT IN PREDATOR MANAGEMENT ISSUES

MY VACUUM CLEANER

- HARD WORKING
- ALWAYS READY TO SUCK UP

TOE

Wayne Anthony Ross sat for confirmation hearings in the Legislature, and each one seemed to raise further concerns. True, the House had praised the man just a year earlier, passing a resolution to recognize him for his distinguished service and advocacy for individual rights and free speech. But that citation didn't require the scrutiny that confirmation hearings did. Ross's views on homosexuality; his activities in political campaigns; his opinions on rural subsistence rights and tribal sovereignty; comments he'd been alleged to make over women's issues and domestic violence—all were trotted out and inspected. Nevertheless, he still might have been confirmed if he hadn't inserted himself in the Juneau Senate Seat issue and given Palin advice that inflamed an already bad situation.

It also didn't help matters that Palin wasn't at the Capital to encourage legislators to vote for her nominee. She wasn't even in Alaska. Instead she was in Indiana, the featured speaker at a right-to-life rally. Ross was rejected by the time she returned.

There were still budgets to pass, and the Legislature, having been burned by the Governor's vetoes and lack of communication the previous two sessions, was eager to assert its role in the budget-making process. Lawmakers took Palin's operating budget and reduced it by $200,000; they took her capital budget—the plan for funding of construction and other time-limited projects—and reduced it by a half-billion dollars. The cuts included several projects that Palin had identified as priorities. If legislators were hoping these cuts were going to force the governor to negotiate with them they were disappointed. She not only agreed to the reductions but offered to help legislators look for more places to cut the capital budget.

Outdoing the Legislature on budget cuts may well have been the most responsible and appropriate thing to do. Unfortunately, by now we suspected that just about everything Palin did had less to do with responsible leadership and more about what was politically advantageous and newsworthy. One more issue, flaring up in the final weeks of the session, contributed to that suspicion.

In February 2009 newly inaugurated President Barak Obama had signed into law the American Recovery and Reinvestment Act of 2009—the "economic stimulus package." The package was a response to the ongoing economic downturn and was intended to save and create jobs through funding for infrastructure, education, health, energy, and other projects. Every state was eligible to receive a designated amount of the $787 billion available; they only had to ask for it.

Palin had spoken for a long time about wanting Alaska to move away from dependence on earmarks and other appropriations from the federal government. During her national campaign and in subsequent public appearances this topic seemed to find resonance with a particular conservative audience who was increasingly concerned with the extent of the federal government's reach and spending habits. She gathered up a list of only a few projects for which she thought stimulus funding was necessary, leaving about half of the $1 billion for which Alaska was eligible on the table. It wouldn't be prudent to accept more than that, she said, reminding Alaskans to be "mindful about the effect of the stimulus package on the national debt." As the session wore on into spring she gradually expressed willingness to accept more funding, but would still not accept money that came with unacceptable mandates. In particular, she was concerned about energy efficiency funds, which she said would require building standards that Alaskans might not be able or want to meet.

Legislators took it upon themselves to meet with federal officials and review the guidelines that came with the package, and were unable to find any requirements that the state wasn't already meeting, or couldn't easily meet. Guidelines for the energy-efficiency program were entirely voluntary.

The back-and-forth over how much to accept, whether it was right to accept, and even whether Palin had ever suggested we not accept the funding, carried on through the spring. Constituent groups that could benefit from the stimulus funding, particularly schools and nonprofit organizations, lobbied intensely for it. Palin would eventually agree to accept all but a small percentage of the federal stimulus money, maintaining to the end that the energy stimulus came with strings that only she believed were substantial. The Legislature would ultimately override that objection and her veto of the funding and accept all the money to which Alaska was entitled.

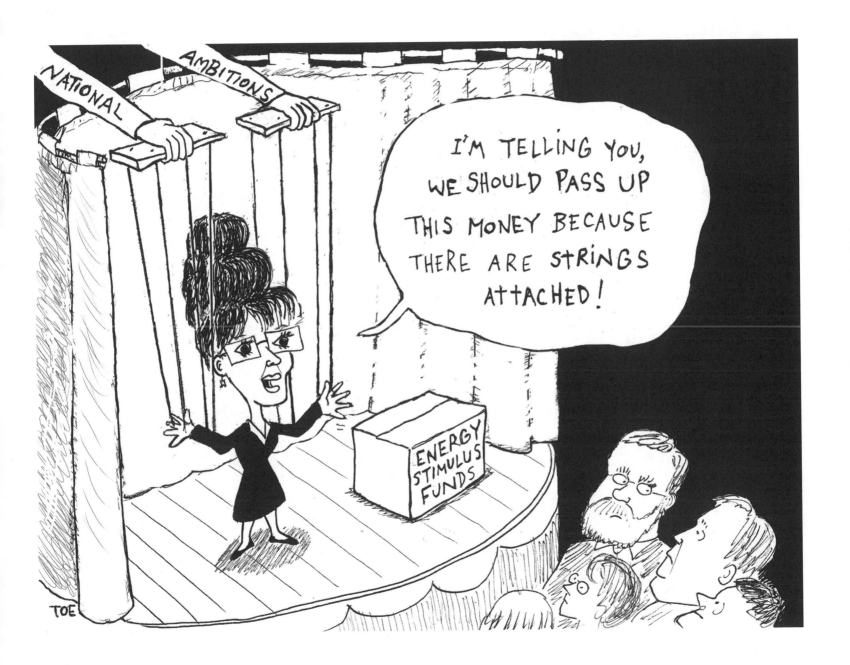

Once the session ended Palin's governorship entered a phase both quiet and surreal, in which serious news from her office was interspersed with the trivial. She established a legal defense fund to assist with the ethics complaints against her; she made a bet with the governor of North Carolina over a hockey playoff. She signed a bill establishing a veterans' cemetery; she signed a book deal. She called for the president to take a firm stand on North Korea; she got into an argument with David Letterman over jokes she found tasteless. She went overseas for a quick trip to visit with the Alaska National Guard troops in Kosovo; and boasted that she could beat President Obama in a footrace.

Serious work on the Alaska Gasline Inducement Act, once her singular focus, seemed to have stalled out. Alaska's congressional delegation, particularly Lisa Murkowski and Ted Stevens, had expressed concerns in the past that our state was not moving quickly enough in securing agreements and constructing a gas pipeline. Now it was newly elected Senator Mark Begich's turn. Around the world, and in far less remote places, corporations and governments were tapping their natural gas reserves and bringing them to market to meet energy needs, he said. Was Alaska missing its opportunity?

Palin's office responded that the complex work of realizing the natural gas pipeline project was moving along as well as possible, given the enormity of the task, and provided a list of accomplishments. Begich's office responded that everything on the list had been said before.

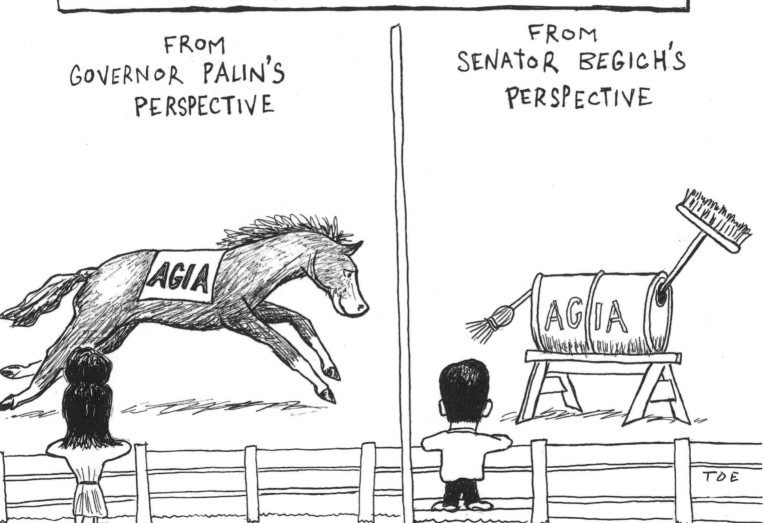

Palin scored a valuable endorsement of her pipeline plan within a few days. Exxon abruptly ended its battles and complaints about her pipeline proposal and now announced that it would be working with TransCanada to help make sure the project was moving. How the two corporations were going to work together wasn't fully explained, but Palin's staff said they'd been studying and analyzing and working (behind closed doors) on the partnership for months.

Exxon's involvement gave us momentary pause. Of all the oil companies operating in Alaska, Exxon had the most turbulent history. The state had a long-running feud with the company over whether it was meeting the obligations of its lease to produce oil on the North Slope, and also whether it was meeting its obligations to produce natural gas from the Point Thompson gas reserves beneath the Kenai Peninsula. And the company's unwillingness to end its appeals and pay up on the Exxon *Valdez* judgment remained a fresh wound even though the accident was now 20 years in the past. But the long-term economic boost that Exxon's support might represent made it easy for us to consider courting the company on yet another resource adventure, even if the way forward was anything but clear.

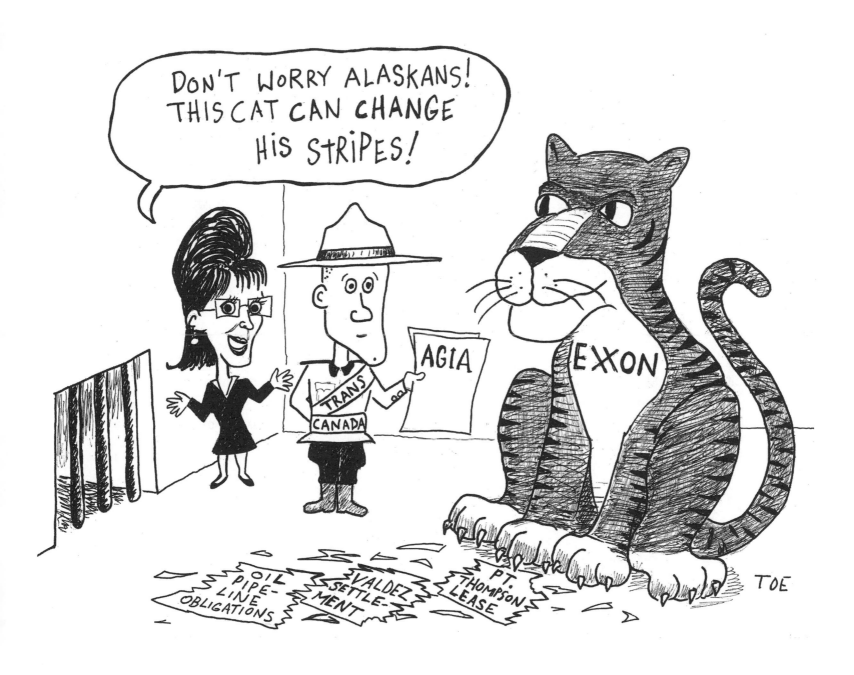

At some point following the vice-presidential campaign Palin got herself a bus, indicating to us that she would be doing a lot of traveling, perhaps trying to rekindle the excitement of her time aboard the "Straight Talk Express" with candidate McCain.

We found irony in her mode of transportation, for if there was one expression that was heard around the Capitol more than any other, it was that Sarah Palin was quick to throw anyone who impeded her ambition *under the bus*. Since being named governor she'd turned loose a chief of staff, two public safety commissioners, two legislative directors, a rural advisor, an education commissioner, a health and social services commissioner, two attorneys general, and three press secretaries. True, some of these individuals weren't dismissed, quitting of their own volition, but our suspicion was that, despite what you may hear about high-level, high-paid individuals suddenly deciding they want to spend more time with their families, few really do so unless work is a really awful place. As we approached the July 4th weekend, two more Palin appointees announced they were leaving—her public health director (terminated) and chief medical officer (quit). Although no reasons for the turnover were forthcoming from the governor's office, the speculation about town was that it had to do with Director Bev Wooley's unwillingness to fudge facts about teenage abortions.

Was it true? We would never get the administration's side of the story. And anyway that story was immediately eclipsed by news that someone else was leaving the governor's office.

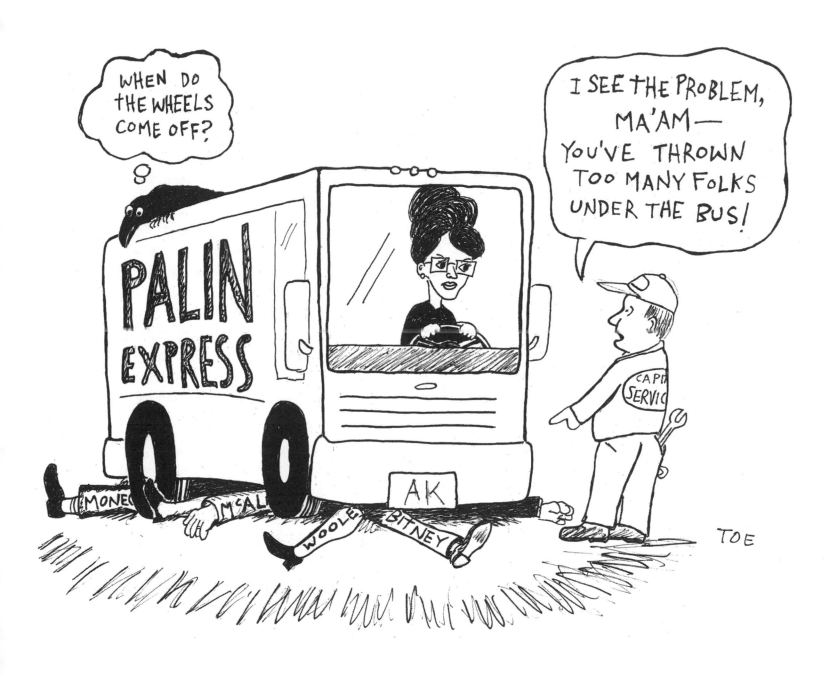

We agreed with those who found Palin's resignation speech to be rambling and baffling. It also was one of the first unscripted and emotionally open windows we'd gotten into our governor. Her voice raced, the basketball and military analogies were overcooked, and she seemed far more nervous than she was in front of the bazillion people who watched her at the Republican National Convention. Reading the official version of the speech later, it was telling to see LOTS of capital letters, informal expressions (nah, um, gotta), and ? misplaced punctuation ? We recognized this as a speech, finally, that she had written herself. And we recognized the author as, finally, a middle-school-aged girl, still coming to terms with social pressures and her own self-image.

Juneau residents, like most Alaskans, reacted with a mix of puzzlement, relief, and frustration. The fighter who never backed down was backing down. The mama grizzly that would protect us to the death was protecting her own interests. If ethics charge after ethics charge was meritless, and indeed seemed to be dismissed, one after another, as meritless, what was it she would be sparing Alaskans from? How is a governor a lame duck halfway through her first term?

In a final twist of irony, after reading the speech and resigning, she disappeared to, of all places, Juneau. Though she'd been expected to speak at a ceremony marking the 50th anniversary of Alaska's statehood, she was nowhere in the crowd when her name was called. She was spotted later pushing a stroller and walking with her family around town, and then sunning herself and Blackberrying from the balcony of the Governor's House.

Her relationship with Juneau was finished. As if to underscore the point, she held "farewell picnics" in Anchorage, Fairbanks, and Wasilla, but pointedly not in the state capital. None of us expected she'd ever set foot in Juneau again.

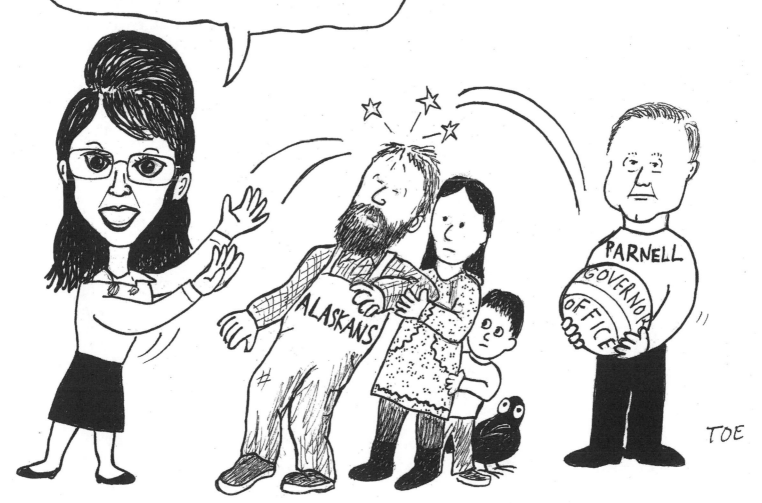

POST PALIN

July, 2009

After announcing her resignation and leaving Juneau, Palin headed to the family's cabin outside Dillingham, a fishing community beside salmon-rich Bristol Bay. The media followed and she granted an interview. Without any clear indication about her future, other than to pursue a mysterious higher calling, rumor filled the vacuum. She was about to be indicted. She was about to get a talk show. She was pregnant again. She was having an affair. She would invite more rumor with occasional statements and hints, but not through interviews or press conferences. Facebook and Twitter comments became her media of choice. If at first it seemed that she was using these media to establish a more direct connection with the public, that soon faded as the public struggled to understand comments that were petty, obscure, and—because she wasn't taking questions—unchallengeable. The *New York Times* noted that personal electronic communication enabled her to be both "ubiquitous and insulated."

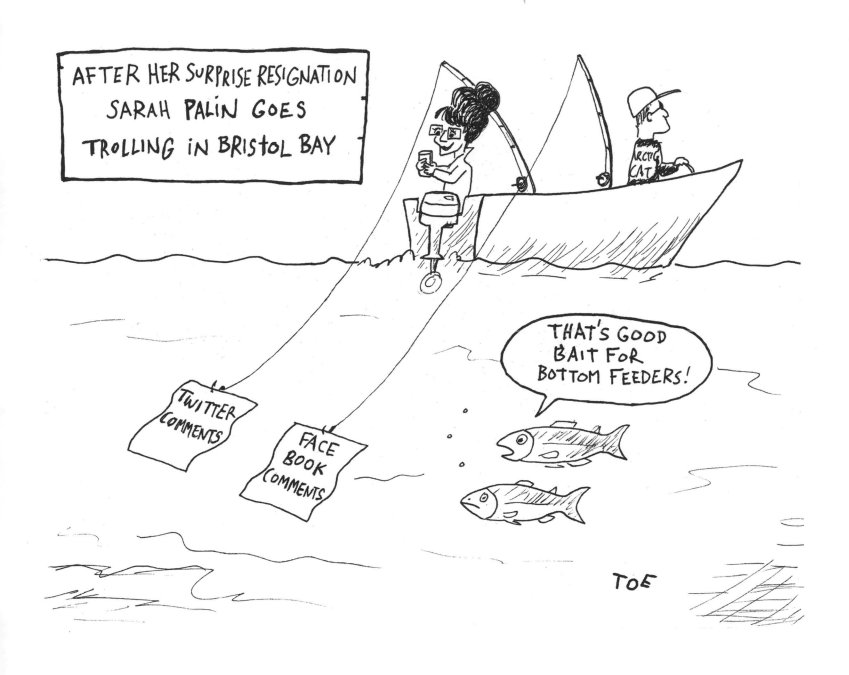

July, 2009

In her resignation speech Palin listed the changes that occurred in Alaska during her tenure. She didn't mention how Juneau had changed. The diminishment of the state capital that occurred under her watch may not have been entirely intentional, but it's hard to see how it could have been worse if she had done it on purpose.

Commissioners and other appointees were no longer required to work here, as they had under Frank Murkowski and previous governors. A number of state jobs went unfilled or had been transferred to Anchorage. The door had been opened to Legislative sessions outside of town (a second one would be held in Anchorage in August), and now the governor's residence could be anywhere. It seemed impossible that any of these changes could be undone. Could future governors lure skilled, wise, and experienced individuals into service in Juneau?

We were interested to see what Palin's successor, Sean Parnell, would do.

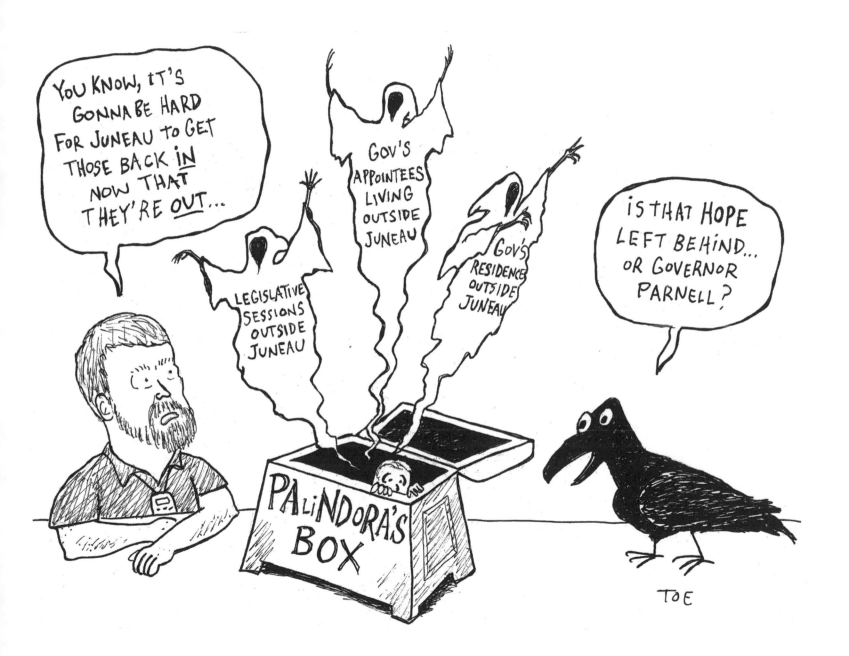

Sean Parnell was no stranger to Juneau. His father served in the Legislature in the 1970s and so as a child he spent a fair bit of time here. The younger Parnell also took a turn as a legislator and lived here during sessions. During that time, he had never distinguished himself as someone interested in moving the capital; in fact he'd bought a home here. Now, as he introduced himself to reporters as the new governor, he said he intended to live here—full-time eventually, after his daughter finished her senior year of high school—and that he'd always enjoyed and appreciated Juneau. He made several appearances around town, at a picnic, chamber of commerce lunch, and to the *Juneau Empire's* editorial board. We welcomed and praised him profusely for these overtures. As far as Juneau was concerned he was off to a good start.

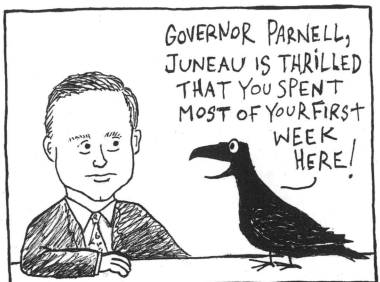

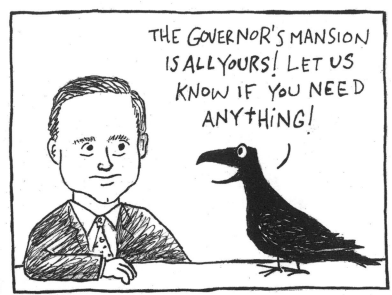

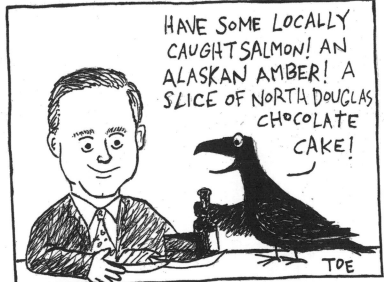

Palin re-entered the public arena with comments about the Patient Protections and Affordable Care Act under construction in Congress, the massive effort to extend health insurance to more Americans and make the insurance industry fairer. The final bill would run some 2,000 pages. Palin provided several paragraphs of comments on Facebook but the remarks that caused a stir were found in two sentences: "The America I know and love is not one in which my parents or my baby with Down Syndrome will have to stand in front of Obama's 'death panel' so his bureaucrats can decide, based on a subjective judgment of their 'level of productivity in society,' whether they are worthy of health care. Such a system is downright evil."

Alaskans by now thoroughly grasped that Palin had no real understanding of complex public policy issues, particularly issues as difficult as health care reform. But reporters and pundits elsewhere nevertheless continued to analyze, deconstruct, and reconstruct her comments and search out justification for them. In this case, there was no justification. There were no death panels in the bill and the claim was completely debunked, including by Republicans otherwise friendly to her. Palin refused to back down and insisted her comment was accurate even after the readers of the web site PolitiFact voted "death panels" the "Lie of the Year."

This was now Palin's *modus operandi*: speaking directly to the audience that adored her through tweets and posts and speeches that were closed to the press. President Obama was the most frequent and direct target of her sarcasm and invective. She questioned his dedication to free markets and free speech; his handling of the wars in Afghanistan and Iraq; and months later was still not letting go of the "death panel" controversy, complaining that his response to her original comments was tactless.

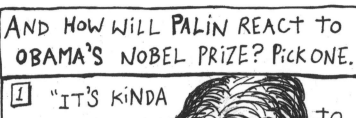

AND HOW WILL PALIN REACT TO OBAMA'S NOBEL PRIZE? PICK ONE.

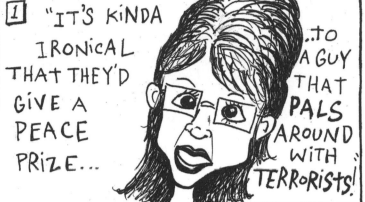

1 "IT'S KINDA IRONICAL THAT THEY'D GIVE A PEACE PRIZE... ...TO A GUY THAT PALS AROUND WITH TERRORISTS!"

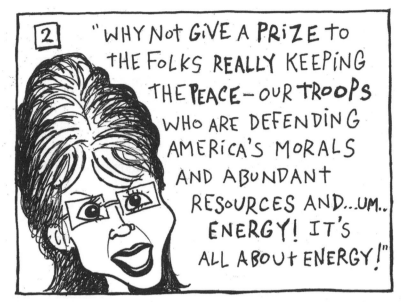

2 "WHY NOT GIVE A PRIZE TO THE FOLKS REALLY KEEPING THE PEACE—OUR TROOPS WHO ARE DEFENDING AMERICA'S MORALS AND ABUNDANT RESOURCES AND...UM.. ENERGY! IT'S ALL ABOUT ENERGY!"

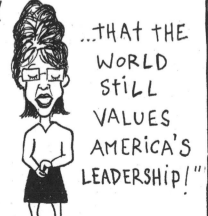

3 LIKE EVERYONE, I WAS SURPRISED. BUT I'M HAPPY FOR MY PRESIDENT, AND PLEASED TO KNOW... ...THAT THE WORLD STILL VALUES AMERICA'S LEADERSHIP!'"

4 "BIG DEAL! I WON A BEAUTY PAGEANT ONCE—WHICH I GUESS IS LIKE BEING A NOBEL PRIZE WINNER... ...EXCEPT THAT YOU HAVE ACTUAL RESPONSI-BILITIES!"

TOE

October, 2009

So little of what Palin had to say through sound bites was revealing or constructive that even her critics might have admitted they had some sense of hope about her forthcoming book. Perhaps in the leisurely, deliberative pages of an autobiography she would, once and for all, demonstrate some thoughtfulness about domestic affairs, foreign policy, health care reform, the economy, and all the things that she might have been able to share had she not been constrained by the theater of a professional campaign or the demands of governorship.

YOU KNOW WHEN IT'S HALLOWEEN SEASON IN JUNEAU...

SOUTH FRANKLIN STREET RESEMBLES A GHOST TOWN...

KIDS KNOCK ON YOUR DOOR LOOKING FOR A HAND-OUT...

STORES DECORATE THEIR WINDOWS WITH GOBLINS, WITCHES, AND OTHER SCARY IMAGES...

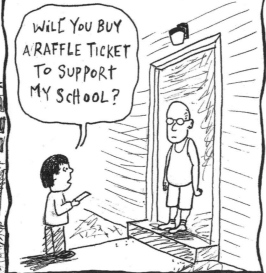

TOE

It was not to be. *Going Rogue*'s most noteworthy aspect in the eyes of reviewers was that it gave Palin an opportunity to describe the story of the presidential campaign, providing perspective on why it went so badly. Otherwise, they generally saw the book as a missed opportunity to lay out a personal, comprehensive vision for the country and the future. She did not discuss in any detail the positions she'd defended in the campaign. The final chapter, "The Way Forward," was only 13 pages long and contained only generalities about returning to Ronald Reagan's America. People who were already Palin fans enjoyed the retelling of her Alaskan background and history; those who were not fans found her to be whiny and vindictive and said she rarely accepted responsibility for any wrong turns in her personal or public lives.

In Juneau, we noted that the book was littered with swipes at the capital city. She complained about its isolation and inaccessibility, which limited her ability to hire commissioners and allowed the political atmosphere to turn sour and foster corruption, "drunken brawls, countless affairs, and garden-variety lunchtime trysts." The *Empire*'s Pat Forgey straight-facedly examined each of her claims and held them up for analysis, finding that for each assertion—such as Palin's claim that cruise-ship passengers enjoyed better access to the Legislature than 80% of the state's residents—there was a contrary, objective truth (the tourist season and the legislative session don't overlap).

With the book's release came promotional appearances. Oprah Winfrey did her best to draw out a more nuanced, reflective, and relaxed portrait of Sarah Palin and came up as short as the rest of us.

January, 2010

The spark of interest surrounding her book died down after the holidays, but Palin found new ways to keep her celebrity sparking. She returned to the medium where she began as a young college graduate: television. The Fox News network was eager to figure out how to capitalize on the appetite some Americans had for her, first as host of a TV special called *Real American Stories*, then as a commentator on Fox News, where anchors could feed her pre-scripted questions, she could prepare exactly what she wanted to say, and they all could create an impression that she was accessible.

Palin looked heavily made up, angular, and garish under the studio lights and display monitors. The interviews were as spontaneous, revealing, and substantial as a living room display in a shopping mall.

Nevertheless, between the book, speaking fees, and TV appearances, Palin was becoming an industry unto herself, a highly profitable one. This, we realized, must have been the higher calling that she'd quit the governor's office to heed: making money—a lot of it.

Her oldest daughter followed in the footsteps of her mother, confirming that the Palin brand was now primarily a money-making brand. Bristol seemed to find riches in whatever entertainment underbelly that came asking. Has there ever been a more diverse resume, based on such a limited skill set, by one so young? Dancing contestant, actress, memoirist, teen-pregnancy-prevention spokeswoman... whatever Americans were willing to buy, it seemed that Bristol Palin was willing to sell.

TAKE IT FROM BRISTOL: TEEN SEX IS A DEAD-END STREET!

OH SURE — I'VE MADE MILLIONS FROM TV SHOWS, A BOOK CONTRACT, AND AS A SPOKES-PERSON FOR ABSTINENCE...

..AND THE FACT IS NONE OF IT WOULD HAVE HAPPENED IF I HADN'T GOTTEN PREGNANT.

TOE

BUT IT ISN'T EASY TO LIVE WITH THE ABSURDITY OF IT ALL! IT GIVES ME CHILLS EVERY TIME I GO TO THE BANK!

Levi Johnson—father, high-school drop-out, *Playgirl* model, pistachio pitchman, author, celebrity has-been—all by the age of 21—carried Bristol's example even further, spinning fame and treasure out of even thinner air. We should have seen it coming from the Republican National Convention, where he looked like a wide-eyed mammal, discovered when the lights came on. After the campaign came the news that his mother had been arrested and convicted on charges of selling drugs; and that he and Bristol were in fact not marrying and were engaged in custody squabbles. Then came his own interviews, in which he sold out Sarah Palin as a disinterested mother, image and money obsessed. She'd take the bait, shooting back that he was pathetic and malicious and—when he bothered to be present at all —a poor influence on his child. The two of them kept it going through their public denouncements, admissions and apologies, both of them alternately angered by and expectant of the public's interest.

We chuckled squeamishly, recognizing that by simply letting ourselves become familiar with the drama—clicking the link, scanning the headline—we were, of course, contributing to it. And we wondered, anxiously, if we would behave so differently if cast into the same whirlpool of attention and potential riches. Why wouldn't we? Why should Levi, Bristol, Sarah or the rest of us be any different than the original gold seekers of Alaska, sacrificing everything they knew about themselves for a nugget of gold, a chance at fortune?

April, 2010

Back here in Alaska we were still picking up the remainders of Palin's governorship. Three years of postponed infrastructure and construction needs now posed a challenge for Governor Parnell, to whom legislators handed a $3.2 billion capital budget—a 10% increase in unrestricted general fund requests from the previous year. The governor vetoed it down to $2.8 billion. Legislators didn't squawk much. After the drama and frustration of the Palin years, both legislators and executive branch staff seemed too tired to do much more than lower their heads and quietly work together.

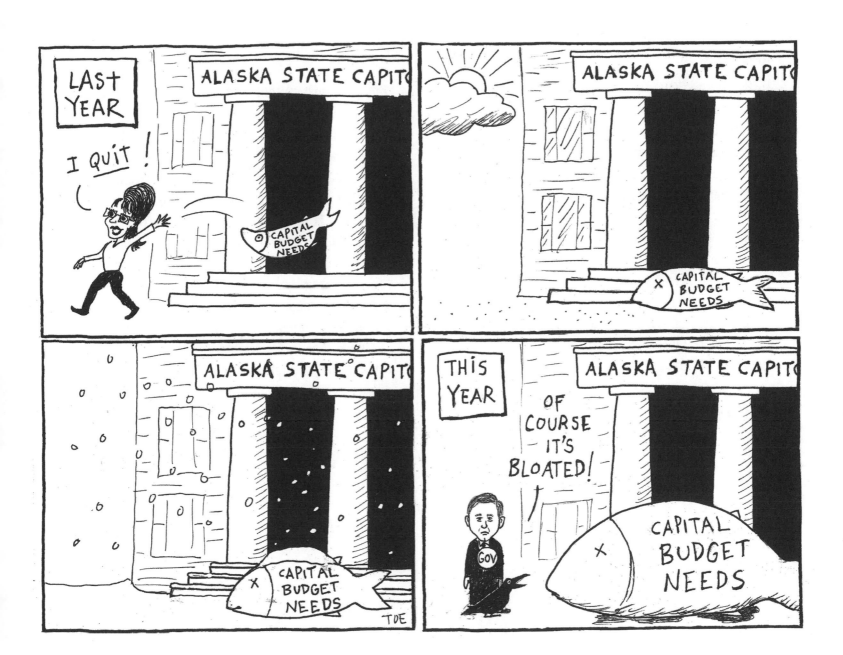

In 2009 and 2010 Palin endorsed a number of congressional and gubernatorial candidates, traveling around the country to speak at their rallies and appearances. They were all Republicans espousing limited government, decreased taxation, and social conservatism: tea party candidates. The populist upwelling was just gaining strength in 2009 and its followers viewed Sarah Palin, more than anyone else, as their symbolic leader. The results in 2009 were mixed, with about as many of Palin's endorsees' winning as losing, and uncertainty whether Palin's backing always helped or hurt. The movement gained a surer footing and scored more victories in 2010.

Many of those Palin endorsed were women, and their candidacies dubbed the "pink elephant movement."

But her most notable endorsement was *against* a woman—Frank Murkowski's daughter, Lisa, who was running to retain her seat in the U.S. Senate. In Alaska, we underestimated the appeal that Sarah Palin and the tea party still had for many of our neighbors, who organized and voted for her candidate, Joe Miller, in force. We woke after primary day shocked that Miller had beaten Murkowski—who, despite her inauspicious beginnings as a senator appointed by her father, had worked hard and gained the respect and appreciation of Alaskans. The state's independents, Democrats, and moderate Republicans rallied behind Lisa Murkowski in the general election, giving her an almost unheard-of write-in victory, and giving the tea party, Joe Miller, and Sarah Palin a clear remonstration.

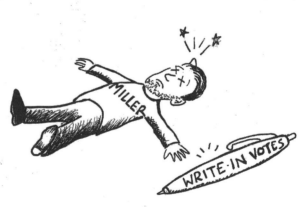

When Palin's second book came out, it all but confirmed for us that she was preparing to run for president. Whereas her first book was more personal memoir, *America By Heart* had a much more political focus, with speeches, writings, and biographies of a variety of political and social figures, interspersed with Palin's observations and how these writings reflected back on her own life and political experiences. Nationally, the reviews fell out pretty much the same way as they had for her previous book: if you liked her, you liked the book. In Alaska, the book struck many of us as a sham, demonstrating only that Palin was getting her money's worth out of whatever packaging and ghost-writing she was paying for. If she was such a fan of Karl Shapiro and James Q. Wilson, for example, why hadn't she cited their influences in her campaigns or political life before? Why hadn't she directed us to their writings back then so we could deepen our understanding of the policies she wanted to pursue? Why hadn't she ever used her knowledge of these individuals and their thinking to disprove the widely held notion that she lacked any intellectual muscle?

By 2011 you could flip through your TV channels and drop into Alaska again and again: *Deadliest Catch*, *Ice Road Truckers*, *Alaska State Troopers*, *Wing Men of Alaska*, *Gold Rush Alaska*, *Flying Wild Alaska*, and more. These reality-based shows mined the suspense and excitement that many Alaskans work and live with every day. Even if we didn't spend much time working outside or under hazardous conditions we enjoyed knowing that others still thought of Alaska as an unpredictable and adventurous place.

Producers must have thought they'd struck gold by combining the nation's fascination with Sarah Palin with the settings of these other shows. *Sarah Palin's Alaska* followed her and her family as they took various excursions around the state. Alaskans noted that many of these trips were the kind frequented by tourists, far too expensive for any of us to take even occasionally. (It also didn't escape our notice that the cast and crew never visited Juneau or anywhere in southeast Alaska on these shows.) The settings were stunning and the situations mildly amusing, but the show lacked suspense (*Would the family find Grandma the right birthday present?*). The producers strained to display family tensions and heartaches, but ironically—when it would have made good financial and dramatic sense—the Palins were circumspect, keeping the cameras and microphones from prying too much, draining the show of excitement. The end result was a nicely produced home video, a public-relations commercial that she was paid to appear in, free advertising for a possible presidential bid—Sarah Palin's Alaska, but not Alaska's Alaska.

MORE ALASKAN REALITY TV SHOWS

AMERICA CAN'T GET ENOUGH!

DEADLIEST CATCH: AUKE BAY!

THIS WEEK: CAPTAIN LARRY TRIES TO CONVINCE 7-YEAR-OLD MEREDITH TO BAIT A HOOK HERSELF.

SNOW PLOW DRIVERS

IF I DON'T EARN BACK WHAT I SPENT ON THIS THING, MY WIFE'LL LEAVE ME!

Courtney Nelson's Alaska

ON TONIGHT'S SHOW I'LL BE RE-ARRANGING MY LIVING ROOM FURNITURE THEN MAKING COSMOS!

TOE

In campaigning for the previous year's elections Sarah Palin had cited on her Facebook page twenty congressional races that concerned her, identifying these contests through a graphic that showed gun sites on a map of the United States with the banner, "It's Time to Take a Stand." We were already familiar with her use of hunting and firearms metaphors like "reloading," "setting sights," and "firing across the bow" in her speeches. Many of us had grown uncomfortable with it long before a deranged gunman walked onto a Safeway parking lot in Tucson, killing six people and wounding Congresswoman Gabrielle Giffords. Giffords herself had complained about the gun-heavy rhetoric a few months before the shooting.

Palin lashed back at the suggestion that she contributed to the shooting in any way, blaming the media for fomenting conspiracy and hate. And it is, of course, too simplistic to attribute a gunman's crazed actions to crosshairs on a Facebook page; if such connections were so clear, it would be easy to prevent such tragedies. But Palin continued to undermine her credibility as a serious, sensible observer of the national mood by reflexively and defensively criticizing "journalists and pundits" for drawing the connection. In fact, around the internet, churches, and offices, many average Americans—Alaskans included—were asking each other, earnestly, whether her coarse dialogue had contributed to an atmosphere that might have, however indirectly, led an imbalanced person to convince himself that his freedom and the country were at risk. If there were ever a time to demonstrate that she remembered what humility and sensitivity were, this was it.

June, 2011

Early in the summer, copies of the emails Palin sent and received as governor were finally released under the Freedom of Information Act. Media organizations and individual suit-filers had waited years for the release of the emails, which had been carefully reviewed and often redacted by lawyers. Palin predicted that they would not produce any damaging or surprising revelations and she was right. In fact, the emails showed her to be hypersensitive about running a transparent and ethically sound ship of state, while also demonstrating how personally she took questions and criticism about her conduct, her platforms, just about anything.

Still, having the cameras and reporters back in town, haunting our office buildings and interviewing passers-by, brought back a bit of the old excitement that Palin had originally brought to Juneau—even though, this time, all there was to photograph were boxes and boxes of white paper. After the emails were sifted through and the media packed up and went home, we felt a bit like we'd purged some old, crowded space in the attic, reclaiming space we could now use for something better.

By summer of 2011, Republican contenders for the next presidential election were declaring their candidacies and bumping into each other at state fairs, straw polls, rallies. Palin appeared at some of them but dismissed any suggestion that her appearances had anything to do with a possible run at president, as if she would have been travelling through early decision states like Iowa and New Hampshire anyway.

Over the past year her favorability ratings nationally had been falling, and although she still had the undying devotion of tea partiers, Christian women, and other groups, even their support was shrinking as they moved on toward candidates that were declared all in. If she would run it looked like she'd be in for a bruising fight. We didn't see any evidence that she had been doing the homework and sharpening the knowledge on subjects she'd need to understand if she were to go up against other Republicans and President Obama. For her to run and win would require an extraordinary combination of circumstances and luck. But we knew that even an unlikely combination of factors could occur in the future, because it had occurred in the past. You could walk around Alaska and meet as many who thought she would run as thought she wouldn't.

Palin put an end to the speculation about her presidential ambitions in early October, a few days after remarking in an interview with a friendly media figure that she wasn't sure having a "title" would be worth the constraints that would be placed on her ability to speak her mind, to call things as she saw them. The remark was more telling than she seemed to recognize. To her the presidency was not the most intense, consuming, and authoritative public-service job in the world, but, rather, a title: a status symbol. The remark also revealed that she actually had never intended to run at all. If holding the title constrained her, she should not take it; if being the president required constraint, she could not do it. Such was her vision of leadership, now, that she did not view it as something within her control, within her ability to harness toward the ends she saw best. Missing is any sense that she could mold the political process and the debate as she'd once done, back when she was the clean, confident reformer Alaska loved.

We accept that, even if she knew months or years ago that she would not run for president in 2012, it still made sense for her not to tell us. The Palin brand requires a certain level of suspense and uncertainty; it's good for sales, good for ratings. Perhaps, having mined her gold, she now truly intends to settle back into her roles and life as mother, grandmother, spouse, Alaskan. Perhaps she'll even cultivate the self-awareness, and excitement for ideas, and the ability to articulate them, that has so far eluded her—so she can actually contribute something constructive to the dialogue the nation so dearly needs to have with itself. If she did that Alaskans could be impressed with her all over again. But it doesn't strike us as likely.

Sean Parnell won the governor's office outright in 2010, shedding what had been, up to then, his biggest claim to notoriety: the man who stepped in when Palin stepped out. While Palin has fallen hard and far in the eyes of Alaskans, Parnell has been a quiet and pleasant surprise. The policy issue that excites him most is the fight against domestic violence and sex assault, a cause that has endeared him across the political spectrum. Even liberals that don't like his politics easily admit that he's a smart and principled man, and welcome his undramatic approach to governing.

In late 2010 Governor Parnell began talking about the need to roll back the aggressive taxation on oil companies that Sarah Palin created in her ACES plan. He is working to convince the public and legislators that the most efficient way to reverse Alaska's declining oil production is by providing oil companies incentives—more tax credits and fewer surcharges—when oil prices are high. If he succeeds he will dismantle his former boss's biggest achievement as governor. Parnell also has his eye on changing the rules of the Alaska Gasline Inducement Act, to encourage active participation from Big Oil and bring Alaska's natural gas to market, and finally make progress on this project.

At this writing the Governor's House in Juneau is draped in plastic and scaffolding, undergoing a massive renovation in preparation for its centennial anniversary. Despite the noise and bustle surrounding the mansion, Governor Parnell lives there nevertheless, and even held his daughter's wedding in the midst of all the construction. Parnell also is holding the line on state government positions moving out of Juneau, insisting that a job be returned here for every one that transfers out. Juneau takes note and appreciates all of this.

Juneau receives as many cruise-ship passengers as ever. They bustle up Main Street and along Calhoun Avenue to see the Governor's Mansion. Even though Palin's residence there was only brief and erratic, tourists will still often ask locals about her, and what we think of her. Sometimes we tell them with brutal honesty; sometimes we walk them through the whole story; sometimes we ignore the question, as it's often not a good idea to talk politics with strangers. Whatever we do, we're always sure to smile and welcome them to town. We know that they just want to make a connection with Alaska and that, for better or worse, Sarah Palin has been a spark to kindle their fascination with our state. We let them take that story or that smile, that connection, home with them, like any souvenir.

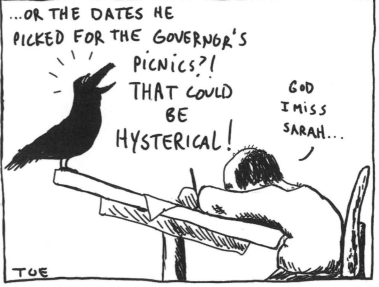

Sarah Palin isn't the subject of many of my cartoons anymore. This is partly because I like keeping my focus on Juneau, Alaska, and the issues that concern my friends and neighbors. Palin still has plenty to say, but her public comments demonstrate that her interests have shifted away from here. Alaska's interests have shifted away from Palin as well. Fortunately there is no shortage of issues, incidents, and personalities from which to draw new material.

Most of what Palin says and does these days simply doesn't make good fodder for cartoons anyway. Not that it isn't colorful and attention-getting: Here she comes now, appearing on the news to defend her version of Paul Revere's famous ride (he was warning the British that the Americans were coming); there she is back on Facebook, telling her followers that it's once again time to "reload" for the next election. These things are already funny, sad, and absurd enough to prompt a laugh, a groan, or a moment's reflection without the need for satire to amplify them further. When comedians enact a skit about her but don't need to change a single word she said, is satire even necessary? And so there's little that new cartoons can do to illuminate or deepen our understanding of what has become of Sarah Palin. Her public life has become a caricature of a public life. She has become her own cartoon.

ACKNOWLEDGEMENTS

The Juneau Arts and Humanities Council for an individual artist grant.

The *Juneau Empire* and its editors and publishers, past and present.

Sarah Olsen of Sarahgraphics for graphic design.

Pat Forgey, Rebecca Braun, and Jeannie Monk for review, corrections and suggestions.

Joan Newman for web support, creativity, and maternal wisdom.

Robert F. Newman for paternal wisdom, humor, and general boosterism.

Paul Cremo for support and advice.

Jim Hale for his letter to the *Empire*. I hope to thank you in person someday.

Karen Forrest, Susan McDonough, and Brian Kertz, for time and encouragement.

My many friends in Juneau who have offered support for this project.
How blessed I am that you are too numerous to mention.

Robert, Grace, and Meredith, for inspiring me every day.

Linda, most of all and for everything. Your love and support has made this possible,
and I'm more grateful than I could ever put into words. Or pictures.

Drawings on pages 81, 99, 103, 133, 139, 143, 147, and 161 are housed in the permanent collection
of the Juneau Douglas City Museum and are reprinted with permission.

Drawings on pages 105, 135, 151, 195, and 197 are housed in the private collection of
Rynnieva Moss and are reprinted with permission.